PAINTING THE
FACES OF WILDLIFE

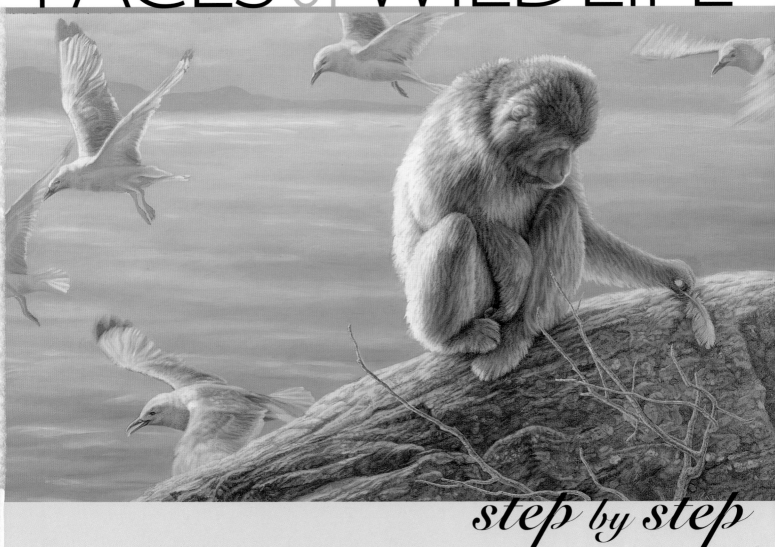

step by step

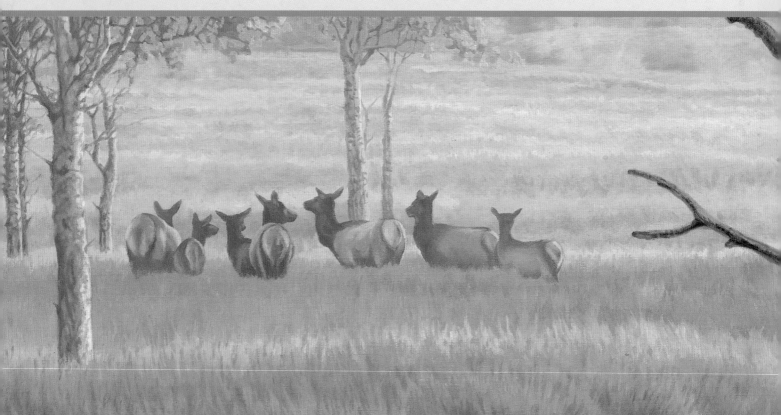

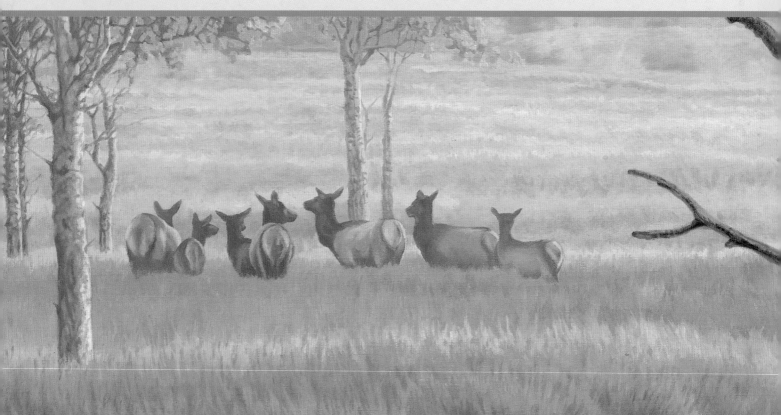

NORTH LIGHT BOOKS
CINCINNATI, OHIO

www.nlbooks.com

Kalon Baughan

& BROOK McCLINTIC BAUGHAN

PAINTING THE
FACES OF WILDLIFE
step by step

TO BROOK...
YOU ARE MY BEST FRIEND
AND SOUL MATE.
MAY WE CONTINUE TO LAUGH
AND PLAY TOGETHER...
TO LIVE IN AWARENESS
AND LEARN COMPASSION
WITH ONE ANOTHER.

TO MY PARENTS AND MY FAMILY,
FOR ALL OF THEIR MUCH APPRECIATED
LOVE AND SUPPORT...
ESPECIALLY THE DEVOTION FROM
MY MOTHER AND STEPFATHER,
ANN AND BOB GOOD.

Painting the Faces of Wildlife Step by Step. © 2000 by Kalon Baughan and Brook McClintic Baughan. Manufactured in China. All rights reserved. No part of this book may be reproduced in any form or by any electronic or mechanical means including information storage and retrieval systems without permission in writing from the publisher, except by a reviewer, who may quote brief passages in a review. Published by North Light Books, an imprint of F&W Publications, Inc., 1507 Dana Avenue, Cincinnati, Ohio 45207. (800) 289-0963. First edition.

Other fine North Light Books are available from your local bookstore, art supply store or direct from the publisher.

04 03 02 01 00 5 4 3 2 1

Library of Congress Cataloging-in-Publication Data

Baughan, Kalon.
 Painting the faces of wildlife step by step / Kalon
 Baughan and Brook McClintic Baughan—1st ed.
 p. cm.
 Includes index.
 ISBN 0-89134-962-6 (hardcover: acid-free paper)
 1. Wildlife painting—Technique. 2. Face in art.
 I. Baughan, Brook McClintic. II. Title.
ND1380.B38 2000 99-056287
751.45'432—dc21 CIP

Content editor: Michael Berger
Production editors: Marilyn Daiker and Jolie Lamping
Designer: Stephanie Strang
Production artist: Kathy Bergstrom
Production coordinator: Kristen Heller

AUTHORS

Kalon Baughan currently resides in Longmont, Colorado, where he works as a professional wildlife painter. Baughan received his bachelor of fine arts degree in 1988 from Albion College, where he graduated with honors and earned the Outstanding Artist Award. He has painted professionally since then, returning to Albion College as their Artist in Residence from 1992 through 1994. Baughan has also served as an instructor for artists at several art symposiums across the country, including the Acadia Symposium and Wolf Prairie Wildlife Art Symposium and seminars at the University of Tulsa and the Northern Wildlife Art Expo.

Baughan has exhibited in many group and one-person shows, and he has been honored as Featured Artist at the Pacific Rim Wildlife Art Show, NatureWorks Oklahoma Wildlife Art Festival, Northern Wildlife Art Expo and the Prestige Gallery Originals Showcase. He has also exhibited at the Southeastern Wildlife Exposition, Wendell Gilley Museum National Wildlife Art Showing, Vancouver International Wildlife Art Show, Michigan Wildlife Art Festival and the Grand National Art Invitational. Baughan has received nu-merous awards and honors in his young career, including several Best of Show, Judges' Excellence, People's Choice and Peer Awards at these various art shows. Baughan is a member of the Society of Animal Artists and has been juried into their prestigious annual exhibit. He was also named Michigan Wildlife Artist of the Year in 1995. Baughan has been interviewed by CNN Headline News as an up-and-coming artist, and has had several articles and references in *Wildlife Art*, *US Art*, *InformArt* and *Art Trends* magazines.

Taking research trips into the wild is Kalon's true passion. He also enjoys figure drawing once a week with a group of local artists, including his wife, Brook. Kalon is an avid canoeist and competes nationally in downriver whitewater races. He also enjoys hiking and exploring in the beautiful mountains of Colorado.

Brook McClintic Baughan graduated summa cum laude, Phi Beta Kappa and salutatorian from Albion College in 1997, with degrees in psychology and fine arts. She is currently earning her Ph.D. in clinical psychology at the University of Colorado at Boulder.

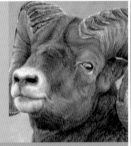
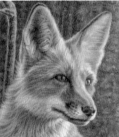

TABLE OF contents

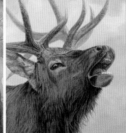

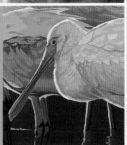

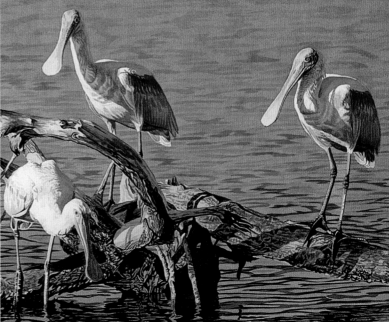

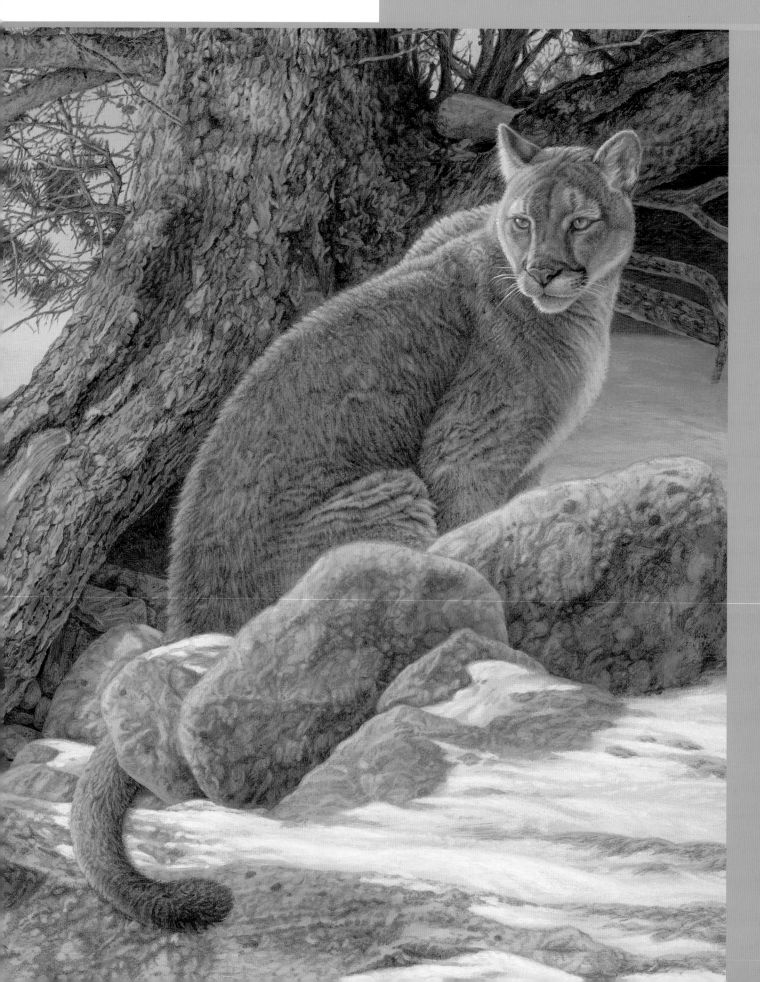

Painting wildlife can be an exciting venture, given all of the captivating aspects of animals and the challenge of portraying them. With all of its complexity, expression and character, the face is perhaps the most difficult element of an animal to capture on canvas. It is the part of a painting to which our eyes are first drawn, and it is where we tend to make contact with the animal, recognizing both its individuality and personality. Given the complexity of the face, capturing the correct anatomy, colors, textures and lighting requires specific study of this most telling feature of an animal. In this book, I have explained my approach to painting the faces of wildlife. I have walked through several paintings of various animals, describing in detail the techniques I use to capture my desired effects.

I have always been drawn to painting portraits of wildlife, with the personal goal of capturing the individual personality of each animal that I paint. For instance, rather than simply producing a visual record of a bear, I strove to capture the essence of the grizzly bear that I came face-to-face with on a photo research trip in Alaska. Like humans, each animal has unique features and expressions that convey its character, which, in my opinion, should always come through in a painting. Of course, in order to create a convincing portrait of an animal, it is also necessary to understand how to correctly capture the anatomy, colors and textures of the particular type of animal. All of these aspects of painting are addressed throughout this book, along with tips on how to find and record the animals you wish to paint, recommendations about types of art tools and materials to use, and guidance through the entire painting process.

I am excited that you are interested in painting wildlife, and I applaud your attempt at tackling the most difficult aspect of wildlife painting—the face. Realize that this is a challenging task, and try not to get discouraged during the process of developing your talent in this area. Please also realize that the techniques and ideas in this book simply reflect my own approach to art and should not dictate how you approach your paintings. My style is very detailed and realistic, but I also have a great appreciation for artists with a more loose or Impressionistic approach. I encourage you to find your own style—one to which you feel most drawn. When starting out, it is a good idea to explore a variety of styles and techniques until you find those that excite you. Once you identify your style, you should continue working to develop it, as a level of consistency in your painting style can make for a stronger body of work.

I also encourage you to set goals for yourself. Realize your own skill level and work within your ability, but always work toward higher and higher goals. Painting is definitely something that requires a great deal of practice and continual development in order to achieve the outcomes we desire in our art. I hope that this book inspires you to continue developing your own talent in this area of wildlife painting. I wish you the best in your painting endeavors and hope that you enjoy capturing the beauty of the magnificent creatures you encounter as much as I do.

LOOKING BACK
detail, Kalon Baughan, oil on canvas,
19" x 30" (46cm x 76cm)

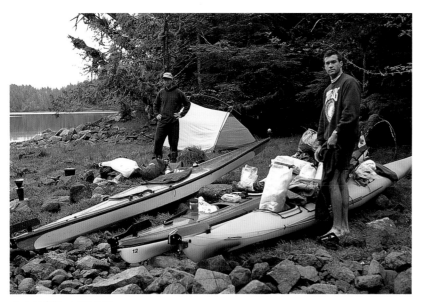

Here are fellow artists Dave Sellers and Bart Rulon during our extended art research trip to the San Juan Islands in Washington. Our kayak trips usually last seven to ten days. Besides packing all of our painting and photography gear, we must also take the usual camping provisions.
(photo by Kalon Baughan)

Getting Inspired by Wildlife

The fact that you have picked up this book leads me to believe that you have already discovered the wonders of the wildlife that surrounds us and have been inspired by it at some level. If so, then you have already engaged in the first step in wildlife painting: finding your inspiration. Going out and finding the subject matter for your paintings can be one of the most exciting and inspiring parts of painting wildlife.

Going Into the Field

Selecting the subject matter for your paintings prior to going out into the field will help you determine where you need to go to find the animals you wish to portray. Different people are drawn to different types of animals, and the animals you choose to paint will generally speak to your personal wildlife interests. If you intend to view the animals in the wild, you need to consider the habitat of the animal, in which part of the country—or the world—the animal lives, and whether it will indeed be probable (or even possible) for you to have a good enough sighting of the animal to be able to paint it. I personally enjoy planning and taking trips into the wild for varying lengths of time with sightings of particular animals in mind. For instance, I might take a month-long kayaking trip in the San Juan Islands to photograph and sketch orcas and shorebirds or a three-month trip in Alaska to view and record grizzly bears, Dall sheep and the myriad wildlife living in the mountains and tundra. Likewise, day trips to the mountains, the shore or wildlife refuges can be equally rewarding.

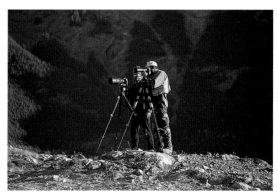

Bart Rulon and I photographing Dall sheep. (photo by Dave Sellers)

ORCAS NEAR THE SAN JUANS
Kalon Baughan, charcoal on paper, 15" x 30" (38cm x 76cm),
collection of Ms. Chris Passant

This is a sketch made from reference photographs taken on our San Juan Islands kayak excursion.

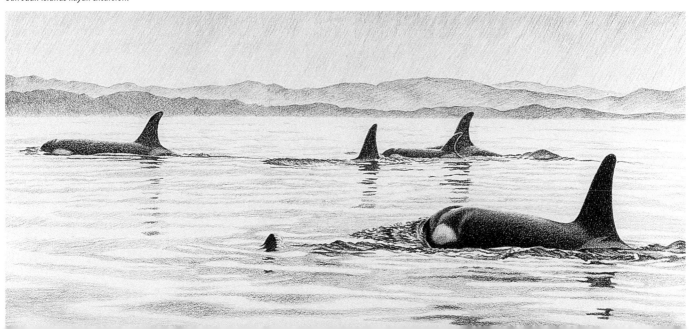

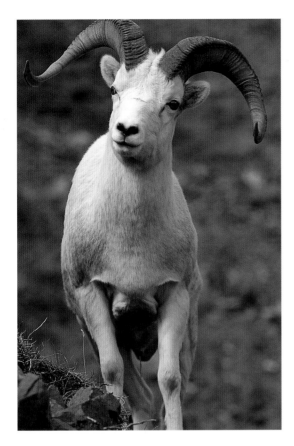

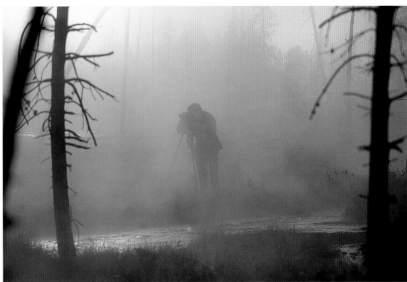

I strongly encourage you to take photography reference in all kinds of weather, as artist Brett Thuma is doing here at Yellowstone National Park. The fog and early morning light create a moody atmosphere. (photo by Kalon Baughan)

Dall ram photographed in Alaska's Denali National Park.
(photo by Kalon Baughan)

If you are unable to, or are not interested in, taking trips into the wilderness, there are also excellent opportunities for viewing animals at your local zoo or a nearby farm, or you can even use house pets as subject matter. I frequently photograph and sketch zoo animals that are difficult to view in nature. For instance, mountain lions are very private animals and are, therefore, challenging to find in the wild.

However, I often obtain beautiful reference material on captive cougars and then later paint them into a more natural background. There is also an element of danger, not to mention expense, time and resources, in going out into nature to encounter such animals as grizzly bears, lions or buffalo. For instance, large mother animals who are protecting their young will frequently attack anyone that they see as a threat. This is another reason to utilize zoos and other such resources for obtaining references.

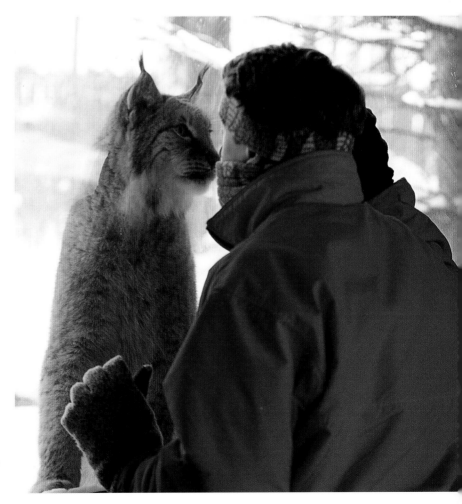

Close Encounter
One way to get close to wildlife is at the zoo. Luckily, there was a glass wall between this Canadian lynx and me.
(photo by Kalon Baughan)

Master Falconer Andy McBride assists me in handling his golden eagle. Viewing animals at such a close range is a great way to familiarize yourself with their anatomy, expressions and individual personalities. (photo by Bart Rulon)

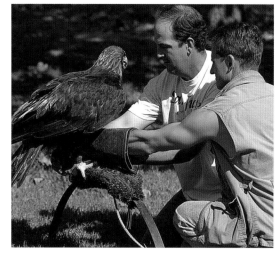

This also brings up another important point about going into the field. It is my firm belief that as artists and as appreciators of nature, we need to always consider the best interest of the animals we encounter. It is important that we not endanger them or their habitat with our actions and that we respect their "privacy" in a sense. For example, getting too close to baby ani-

Overcrowding in the Parks
This is what I try to avoid. Not only is my wildlife experience diminished by the crowd, but this overbearing group runs the risk of stressing the animal they are photographing, which in this case is a green-backed heron at Florida's Everglades National Park. (photo by Kalon Baughan)

mals can cause the parent animal to abandon their young. Likewise, feeding wild animals or polluting their habitat can endanger them by altering their natural system. In other words, showing consideration and respect for nature should always override getting the perfect photo or sketch for your paintings.

Techniques for Field Research

There are various ways to use field research for your paintings. Some artists photograph animals and then use the photographs as reference material. Others do sketches in the wild to later paint from, while other artists actually complete their paintings in the field. All of these can be valuable and effective field techniques, and you should choose the techniques that you find are most helpful or rewarding for you.

[PHOTOGRAPHY]

I frequently use my camera to capture animal reference material in the wild. I find that working from photographs allows me to achieve the amount of detail that I want in my paintings. Photography can be an invaluable tool in this capacity, and having a still and lasting image of your subject matter to paint from can definitely enhance your painting skills. In fact, many of the early wildlife masters, going back as far as Carl Rungius and Bruno Liljefors, often used photography as a reference tool. For me, being able to bring photographs back to my studio allows me to work on a painting for several weeks, with multiple references of specific ex-

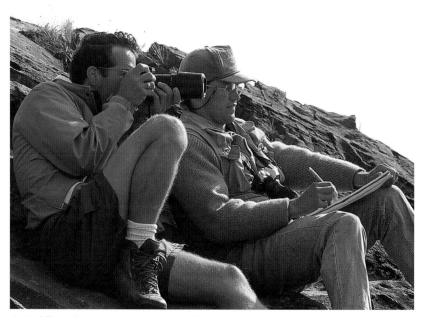

Artists Sellers and Rulon photographing and sketching in the field. (photo by Kalon Baughan)

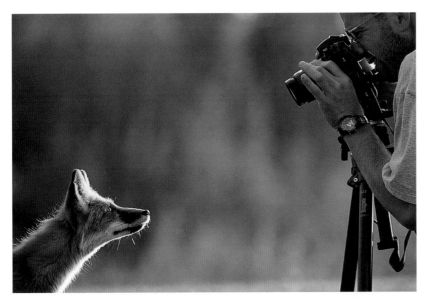

Occasionally, even wild animals drop their guard around humans when they are curious. (photo by Kalon Baughan)

pressions, lighting, body postures and actions. I've never been able to do a complete painting from one photograph. Instead, my paintings are compilations of images of animals and landscapes from various photographs. For example, I may use the muzzle of an animal from one photograph and the expression in the eyes from another to achieve a more captivating painting.

I use only my own photographs, as I feel that going out and obtaining your own references is an invaluable element of the creative process. I consider photography an art form in and of itself, and for me, the painting process actually begins with my photography. I use 35mm cameras, and my favorite lens for photographing animals in the field is a 300mm lens. This is a versatile lens for photographing both small and large animals. A tripod is essential when photographing with a large lens, because shooting freehand often blurs the image as a result of vibration. I also carry a small lens, referred to as a doubler, that doubles the magnification of the lens. This is particularly useful when photographing small animals, and it doesn't take up much space in your backpack. I'm frequently asked which speed of film I use. I tend to use 100-speed slide film, which is a slower speed. The general rule of thumb is the slower the film speed, the greater the definition or detail in the photograph. However, the drawback of using a slow-speed film is that you must use a tripod because the camera shutter speed is slower. I also want to note that although photography gear can be very expensive, most gear can be rented at photography shops at reasonable rates. Renting is also a good way to determine which types of camera gear you might want to eventually purchase.

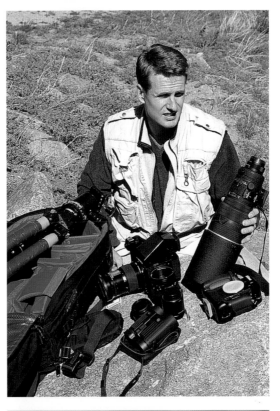

Here I am pictured with some of my most important camera gear. I recommend insuring your gear. There is always a chance that your gear may be stolen or damaged while in the field. (photo by David Haskins)

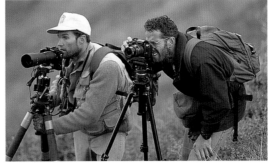

Day trips into the field can prove very productive for photographing animals. The only downside to this is that you must carry a great deal of gear. (photo by Kalon Baughan)

Because I prefer to photograph in the wild rather than in zoos, I have found that building blinds is the best way to photograph animals that are difficult to approach. I've used this technique on both land and water, and though it takes a great deal of patience and time, the results are rewarding, as the animals tend to behave much more naturally when they are unaware of human presence. Using a blind has allowed me to observe unique animal behaviors, infinite types of lighting and breathtaking landscapes. These experiences revive my creativity, inspire me on a profound level and are an element of my artistry that I deeply cherish.

[SKETCHING AND PAINTING IN THE FIELD]

Although photography can be a useful tool in painting, the fundamentals of drawing and painting must not be abandoned when using photography. In fact many artists refuse to use photography at all when painting because it is a very different experience to draw or paint directly from life. Photography often flattens the three-dimensionality of an animal and can alter colors or hide textures that might be better seen with the naked eye. Sketching directly from the animal forces you to really observe the shapes and proportions of the animal's anatomy, and it can be an exciting and rewarding approach to

BUILDING A FLOATING BLIND

1 MATERIALS
- ¼" (6mm) plywood cut to 6' × 3'8" (1.8m × 1.1m) dimensions, with a 30" × 22" (76cm × 56cm) cutout for your legs to drop through
- PVC pipe and connectors
- Flotation/pontoons
- Camouflage material

2 Attach flotation to the plywood frame.

3 PVC pipe should be cut and assembled to attach to the plywood frame in a cagelike shape that will later support the camouflage material.

4 This is what the floating blind looks like when the PVC pipe and flotation are attached to the plywood platform.

5 Check to make sure that the blind is sturdy and large enough to support your weight.

6 Cover the PVC pipe structure with camouflage material. Be sure to cover the top and all sides of the blind so that animals will not see your movement inside the blind.

7 Cut a slit in the back so that you can enter and exit the blind. I use safety pins to hold the slit shut.

8 Last but not least, attach representative foliage to the blind to further enhance your camouflage. You will need waders when spending extended amounts of time in cold spring or fall waters.

(All photos by David Haskins unless indicated otherwise)

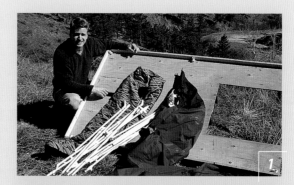

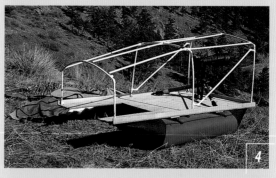

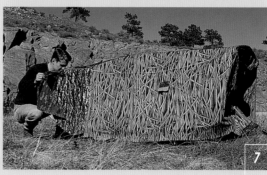

recording your subject matter. For this field technique, take along various forms of graphite, charcoal, pastels and pads of sketching paper. If the animal is a quick mover, this will be a great opportunity to practice your gesture drawing techniques. If the animal remains somewhat stationary, you can often finish a detailed drawing or several sketches of the animal. Upon returning from the field, you can either work up the sketches or simply use them as springboards for your paintings.

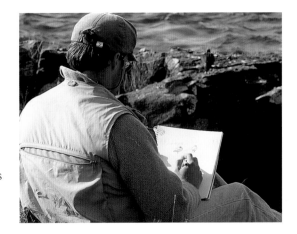

Rulon sketching an oyster catcher in the San Juan Islands. (photo by Kalon Baughan)

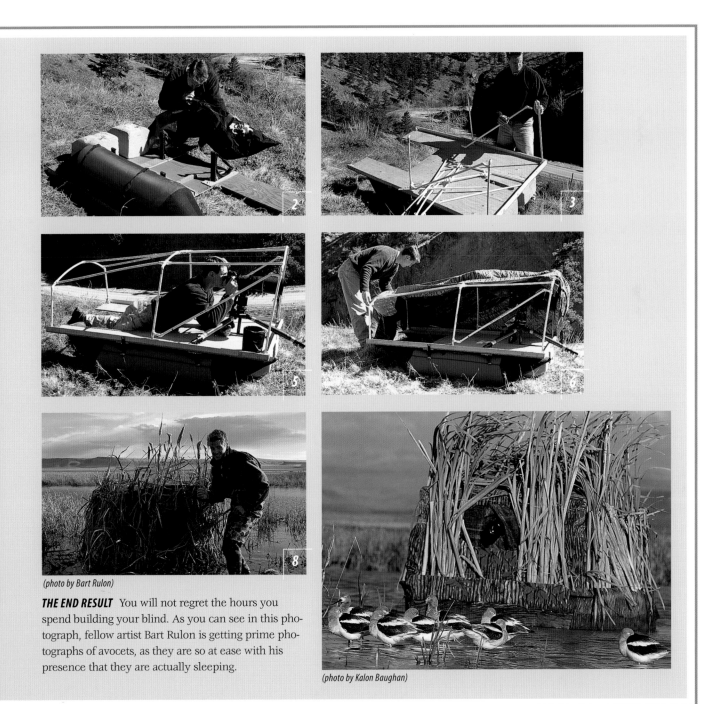

(photo by Bart Rulon)

THE END RESULT You will not regret the hours you spend building your blind. As you can see in this photograph, fellow artist Bart Rulon is getting prime photographs of avocets, as they are so at ease with his presence that they are actually sleeping.

(photo by Kalon Baughan)

ARCTIC DREAMS
Kalon Baughan, graphite on paper, 12" x 18" (30cm x 46cm), collection of Robert and Kathy Swanson

This is a graphite drawing made from photographic reference taken at Point Defiance Zoo in Tacoma, Washington.

Field painting can also be a rewarding experience. This requires bringing a compact palette, brushes, medium, a painting surface and a portable easel into the field with you. Once you have found your subject matter—preferably one that will remain somewhat stationary long enough for you to paint it—set up your easel and materials at an optimal distance from the animal and begin painting. It is important to realize that when painting *plein air*—that is, outdoors—you need to be aware of the way that sunlight changes over time. The lighting and shadows of your subject may change drastically over time, so it is a good idea to capture the lighting aspects of a scene at one period of time to keep it consistent throughout the painting. Field paintings can serve as sketches or *underpaintings* to be completed in the studio, or you can finish the painting in the field, creating an *alla prima* work of art—which means to finish

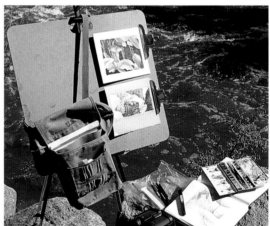

I prefer to sketch or paint with watercolor in the field. I take a tripod to hold my clipboard, and an old army bag that holds my paints, pencils, paper and sketchbook. I also always take my binoculars with me into the field. (photo by Kalon Baughan)

the painting upon the first attempt. A good technique for completing highly detailed paintings in the field is to find a stationary animal, such as a bird on a nest, and set up a spotting scope on a tripod at a comfortable location to the animal. You can then quickly shift back and forth from viewing the animal through the spotting scope and capturing the details you observe on canvas.

Preparing to Paint
[MATERIALS]

Approach every painting with the attitude that it could turn out to be a magnificent work of art. Insist on using only high-quality materials that will stand up to the quality of the work you put into the painting.

Field Painting Excursion
Dave Sellers, Kalon Baughan, Greg Beecham and John Phelps enjoy a day of painting and sketching in a scenic valley in Dubois, Wyoming. The camaraderie we enjoy during these excursions helps generate positive energy that transfers directly into our paintings.
(photo by Lu Beecham)

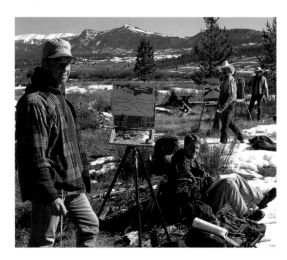

[PAINTS]

There are various types of paint that you may choose to use, depending on the type of painting you wish to engage in. These include watercolor, gouache, acrylic and oil paints. The first three types of paints are water-based, requiring only the use of water rather than the turpentine, solvents and mediums used with oil paint. Painting with oil paints tends to take a little longer because of the slow drying time, and the turpentine creates fumes that some artists do not care to be around. However, there is a line of oil paints that has recently been introduced to the market that uses only water for thinning and soap and water for cleaning up. Water-based paints are popular for field painting. They are less messy and highly portable. They also have a faster drying time than oil-based paints. Watercolors can be used to produce thin, loose washes. Gouache, which is an opaque watercolor, acrylics and oils can be used to create a more detailed rendering with greater color saturation. The complexities of the different types of paint are too numerous to mention here. Experiment with different paints until you find the medium that meets your specific needs, whether it is a paint that you can easily use in the field, a paint with either a fast or slow drying time, or a painting process free of toxic solvents for thinning and cleanup.

I primarily use Winsor & Newton watercolors and oil paints for my paintings. I use watercolors in the field because they are clean, quick and small enough to travel with. However, most of the paintings I complete in my studio are oil paintings, because I appreciate the end results that I obtain with this classic medium. I feel that there is no medium that can match the color intensity and luminosity of oil paint. With their slower drying time, oil paints also offer me the ability to work much slower, which is helpful in my blending and dry-brush techniques. For this reason, most of the painting demonstrations in this book will be oil paintings using Winsor & Newton artists' oil colors.

Every professional artist that I know has a different color palette. As with every other aspect of painting, you need to experiment with and develop your own palette based on your own style and subject matter. There are also different grades of paints, differing in quality as well as price. The two basic types are *student grade* and *artist grade*. I prefer the artist, or professional, grade. They tend to have more pigment and less medium, which provides much more intense color. The drawback, of course, is that these paints are more expensive. However, if you want the color in your paintings to be rich and resist fading over time, I would recommend that you invest in the artist-grade paints. You should plan on each painting being important enough to want it to pass the test of time.

Various mediums are used with oil paints to thin the paint, to aid in the drying process or to give the colors more intensity. Again, I recommend experimenting to find the mediums that

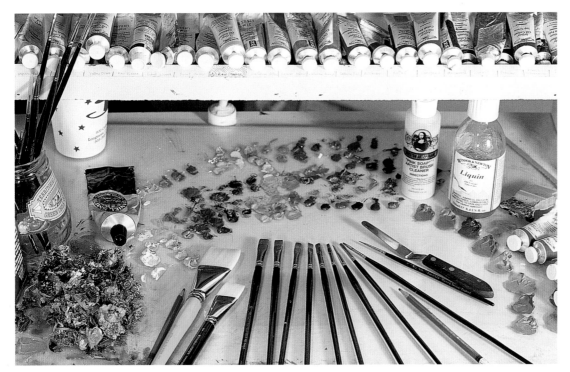

Tools of the Trade
This is my painting station. All of my oil paints are arranged on a shelf above my glass palette for easy access. Also shown are the brushes I use most often, a palette knife, brush cleaner and a bottle of oil painting medium. (photo by Kalon Baughan)

best suit your individual painting needs. I tend to use two different types of mediums when painting with oils. My favorite medium is Liquin, made by Winsor & Newton. It speeds the drying time of oil paint, and when mixed with the oils, its thinning properties make the paint glide off my brush more easily. The other medium, Transparent Blender, is made by Daniel Smith. This tends to slow the drying time of oil paint and is great for blending.

[BRUSHES]

There are many types of paint brushes available, varying by size, brush shape and type of brush bristle. I use sable bristle, flat-shaped oil painting brushes for roughing in my paintings. And generally as the painting goes from underpainting to greater detail, I prefer to go with a smaller brush size. Specifically, I use a ¼-inch (6mm) to a ½-inch (12mm) flat brush for roughing in my paintings and will often use a no. 0 or no. 1 brush for detail work, varying between a round and flat brush in either size. For watercolor painting, I use the same shape and thickness of brushes as I use for oils, although the handle lengths of watercolor brushes are generally much shorter. I prefer to use sable brushes with both mediums for several reasons. Sable hair is a natural fiber and is very soft. When using it with oil or watercolor, it tends to aid in blending while keeping a relatively smooth painting surface, which is how I personally prefer to paint. However, the drawback of using sable is that it is the most expensive kind of brush; you may find that synthetic sable works just as well for you at a much lower cost.

It is very important to clean your brushes thoroughly after each use, especially if you are

going to invest in sable brushes. Your brushes can last quite a long time if properly cared for, which requires taking great care in cleaning them after each day's painting. I recommend cleaning the brush thoroughly with turpentine and then using a commercial brush-cleaning agent, such as Winsor & Newton's Artgel Hand and Brush Cleaner, which not only cleans the brush but also puts oils back into the brush to prevent it from drying out.

[PREPARATIONS]

When painting with oils, I paint on both canvas and panels. When painting on canvas, I prefer to paint on a preprimed linen canvas with a very tight weave, which allows me to paint with great detail and a smooth surface. However, the drawback to using a preprimed canvas is that stretching the canvas onto stretcher bars can be a wrestling match. I often like to paint on prepared Masonite panels, because they provide a smooth, stiff surface that also allows for a great amount of detail. I suggest using untempered Masonite, which should be prepared with vigorous applications of gesso on the front, back and side of the board in order to totally seal the panel. When choosing your painting surface, you should always consider its archival quality, as this again reflects on the quality of your painting and will determine whether your painting will last through the years.

The Painting Process

Once you have your materials and your painting surface prepared, you are ready to begin painting. It is important to find a painting space that has the room and ventilation that you need, as well as the type of lighting you desire. The ideal natural lighting is a window that never gets direct sunlight, which is generally a north-facing window. With this type of lighting, your painting shouldn't be affected by the changes in lighting throughout the day. Artificial lighting ensures you a consistent source of lighting and also allows you to work at night, which is important if you are a night owl like myself. Following are some general tips on the painting process, from beginning the painting to finishing and framing it.

This is a photograph of me painting in my studio. You can see that I am painting on a gessoed Masonite panel attached to a stable, plywood easel. To my left is a painting in the preliminary stages, and above my head are study drawings that I used to plan other paintings. (photo by Kalon Baughan)

I like to separate my watercolor painting from my oil painting in my studio to avoid contaminating the mediums. (photo by Kalon Baughan)

[PRELIMINARY SKETCHES AND DRAWINGS]

When sketching in the field, you should always keep in mind the importance of drawing skills, anatomy and composition. The more accurate your sketches and preliminary drawings, the easier it will be to complete a successful painting. In fact, a good way to improve your paintings is simply to work at your drawing skills. For

UNTITLED
Kalon Baughan, graphite on Arches paper, 11" x 14" (28cm x 36cm), collection of the artist

Drawing the human figure can enhance your ability to capture anatomy in other animals, as well.

instance, I draw from the human figure on a regular basis, both because I enjoy figure drawing and because it actually improves my drawing skills and my ability to correctly capture anatomy and musculature. I find that this practice directly leads to improvement in my paintings of animals. Similar to figure drawing, when painting wildlife I am trying to capture the essence of the individual rather than simply rendering a generalization of the animal. Furthermore, working on the general quality of

This is a preliminary sketch where I have worked out all of the composition and value problems before transferring the image onto the painting surface.

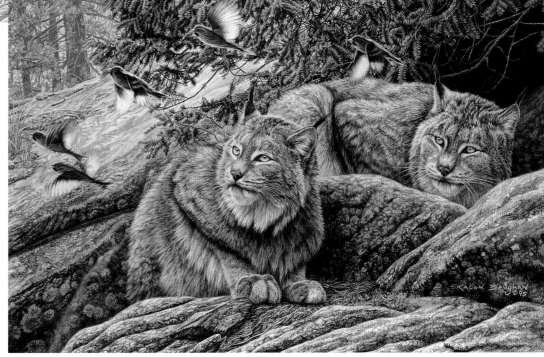

CONTEMPLATION
Kalon Baughan, oil on canvas, 17" x 26" (43cm x 66cm), collection of Brent and Cheryl Granger

The only major difference between my preliminary sketch and the finished painting is the placement of the birds.

your lines and shading can also lead to more convincing and compelling paintings.

It is also important to think about the composition of your paintings during the sketching process. Placement of the animal in your painting can be crucial to the overall effect of the painting, so it is a good idea to work out your composition in sketches before committing to it in paint. For instance, it is usually not a good idea to place the animal exactly in the center of your painting. This is often referred to as a "bull's-eye" composition, and it is generally felt that there are many other more interesting ways to compose a painting. In addition, creating interesting diagonals in your composition can help direct the viewer's eye to the intended focal points of the painting.

[TRANSFERRING YOUR IMAGE TO THE PAINTING SURFACE]

After you have worked out a sketch and a composition that satisfies you, there are much easier ways to transfer the image to the painting surface than to simply start from scratch with paint. One technique that I often use is to first trace my sketch onto tracing paper, adjusting the composition until I am satisfied with the image, and then I use a soft pencil to retrace the lines on the reverse side of the tracing paper. I then place this side of the paper on the painting surface and go over the lines with a harder pencil in order to transfer the pencil lines. I prefer to continue drawing on the painting surface, shading in the values that I will later establish with paint. After completing the drawing, I secure the drawing by spraying the painting surface with a spray fixative. This prevents me from accidentally smudging the drawing or mixing graphite into the paint.

[PAINTING PROCEDURE]

Once the image is intact on the painting surface, you can begin applying paint. When working with oil, it is advisable to first tint the canvas with a wash of a color so that you are not working on a pure white surface. This wash needs to be transparent so that the drawing can still be seen. I recommend a wash of Burnt Sienna thinned with turpentine. After laying down the wash, it is highly advisable to go from thinner layers of paint to thicker layers to avoid later cracking in the paint. I will provide further details and advice on the painting process throughout the rest of the book.

[VARNISHING AND FRAMING]

Upon determining that your painting is finished, let the paint dry for as long as you can before varnishing and framing. Appropriate drying time will, of course, depend on how thick your paint is, how much medium or drying agent you used during the painting process and which type of paints you used. A thickly painted oil painting should generally be allowed to dry for six months to a year, whereas a thinly painted oil painting can be completely dry within two weeks to a couple of months.

I strongly recommend varnishing your paintings after they have been allowed to dry completely. Varnish protects the canvas and paint, and it can bring out the true richness of the colors. It tends to especially enliven the dark colors in a painting, bringing them back from a matte dark to a very rich, intense dark. Varnish can also be used to give the painting a glossy finish, which is what I prefer, but other artists use a matte or semigloss varnish, as well. I often use a

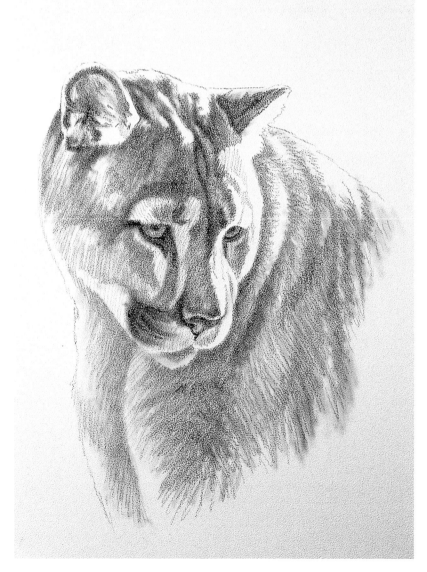

Drawing transferred onto the painting surface.

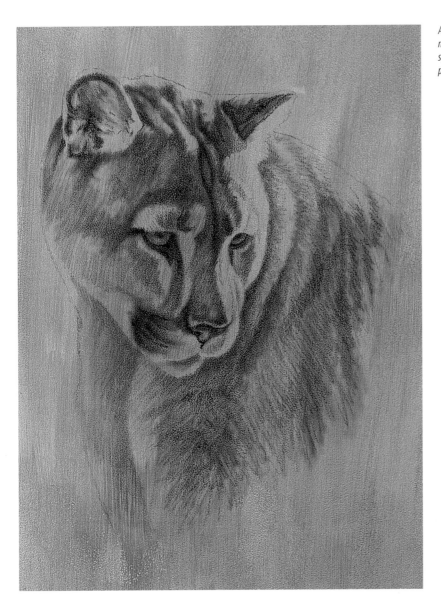

A transparent wash provides a neutral value from which to springboard your painting process.

spray varnish, because it is easier to apply, but there are also varnishes that are brushed onto the painting.

After the varnish has completely dried, you can consider framing your completed work of art. Some artists prefer to frame their paintings, though others do not. I personally feel that the right frame can greatly enhance a painting. There are many different types of frames, and which type you choose will depend on your personal taste, as well as your budget. Choose a frame that truly complements the painting, both in color and style. I generally have my frames custom-made for each painting by a professional framer, who takes into consideration whether the individual painting is warm or cool in tone when choosing the patina, or finish, of the frame. It is also important to have your paintings framed by someone who is skilled at framing original works of art and who is known for quality framing. This is important in terms of

the conservation of your paintings as well as their presentation. If you believe in your art, it should show in the quality of the presentation. The frame in which you present your painting makes a statement about your own feelings about the quality of your painting, and this statement should always be resoundingly positive.

BEARS

hroughout history, bears have been considered a great symbol of power. As the largest carnivore in North America, bears have been feared by many cultures for their unpredictable and dangerous nature. However, they have also been equally revered as gentle, nurturing animals. The Blackfeet and the Ute intertwined myths of the bear into their daily lives and often included bear imagery in their shelters, clothing and weapons to give them special mystical powers. In modern society, the bear has become a majestic symbol of the wilderness. Because they need a large area to roam and forage for food, bears are considered a good indicator species of places that are still truly wild.

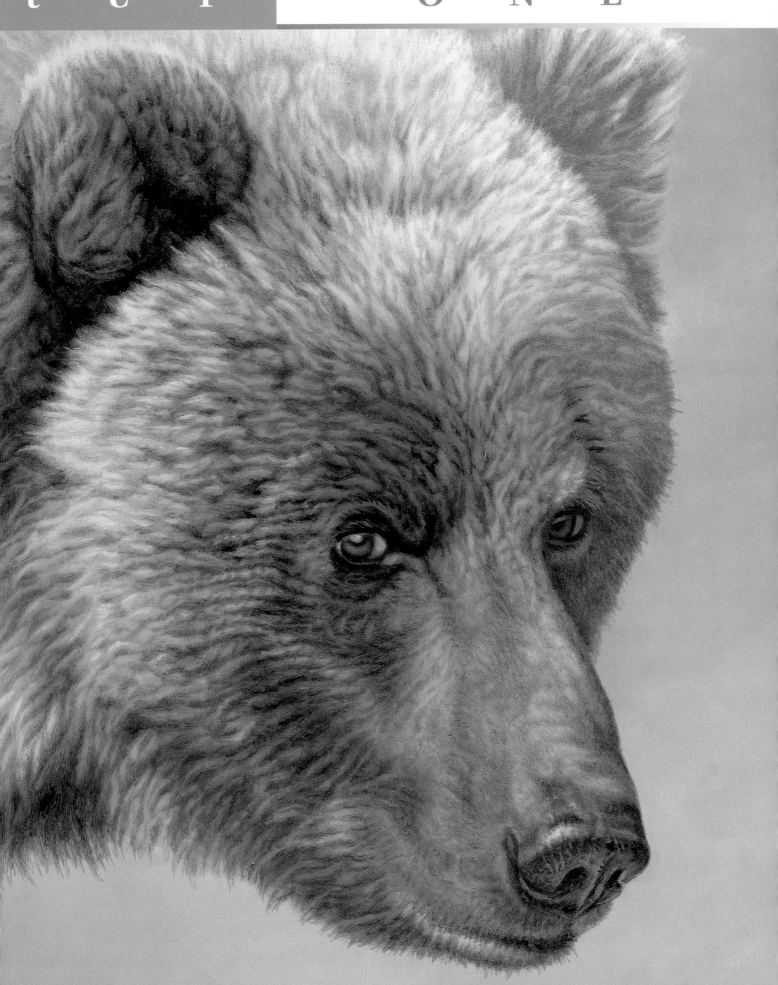

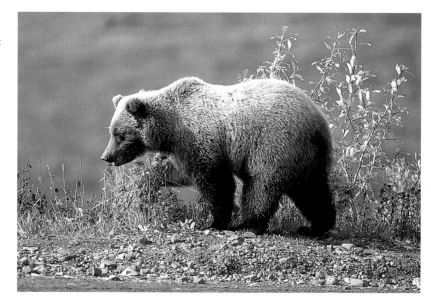

Reference Photo: Grizzly Bear
I photographed this grizzly in Denali National Park, Alaska. This is a good example of the quality of photographic painting reference that you could expect to get from the safety of a vehicle with a 400–600mm camera lens. (photo by Kalon Baughan)

Reference Photo: Black Bear
I photographed this black bear in the wild in western Canada. Notice that it does not have the distinct shoulder hump of the grizzly. Also, although this bear is black in color, there are several distinct color phases that black bears go through, including blond and brown, with black being the most common. (photo by Kalon Baughan)

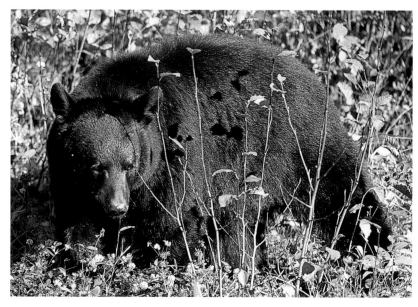

Historically, bear imagery was frequently used in the paintings of the great masters of sporting and western art. In those early paintings, the bear was often personified as a beast to be feared—a villain of the natural world. However, contemporary painters have tended to tap into the more reverent aspects of bear energy.

Today, bears can be viewed at many of the great national parks. I have personally had great viewings of black and grizzly bears in Yellowstone, Glacier and Denali National Parks. Because of the unique habitat of the polar bear, the best place to view these impressive animals is in Churchill, Manitoba, in Canada, where a large concentration of polar bears gathers annually during late fall.

Bears essentially live to eat, preparing themselves for their annual hibernation. Therefore, although bear habitat is incredibly varied, you are most likely to find bears near their food sources. For instance, grizzly bears can often be found along rivers containing spawning salmon and trout, near huckleberry and blueberry bushes and in open grassy meadows along mountain slopes. Grizzlies once roamed a large part of northwestern North America, but in recent times they have been pushed back to areas specifically protecting them—areas where human beings do not reside. In an area where grizzly bears are concentrated, you will often find the well-worn paths used by centuries of bears. Be very careful when using these routes, as bears will often rest just off of these paths and

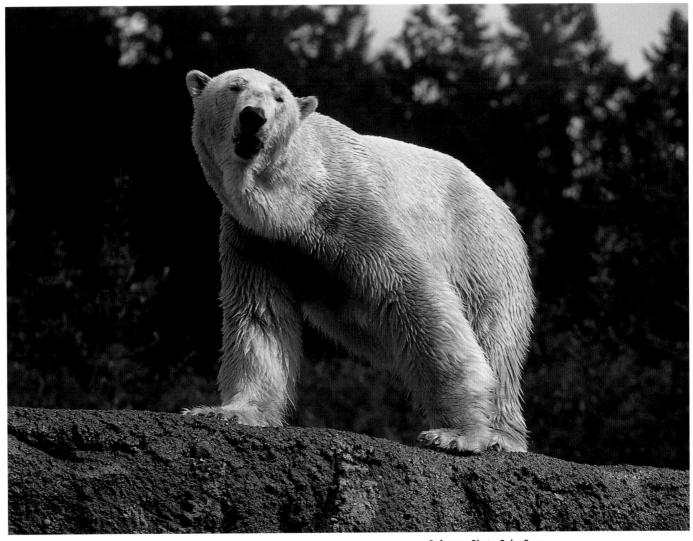

Reference Photo: Polar Bear
Notice the lush green background in the photo of this polar bear. The reason for this is that I photographed this bear at the Point Defiance Zoo in Tacoma, Washington. Remember, not all of your photographic reference has to come from the wild. (photo by Kalon Baughan)

can be easily startled by unexpected visitors.

Black bears are the most widely spread species of bear in North America, primarily feeding from berry patches, grassy meadows and garbage dumps. Despite the fact that black bears could inhabit your state, the chances of seeing one are very slim, as they are shy, elusive animals.

Polar bears are the most regionally specific of bears. However, they inhabit an enormous range, as the entire Arctic region can be called their home. Polar bears can be found in concentrated areas, waiting for sea ice to form platforms from which they hunt seal and walrus.

Here I am with Bart Rulon searching for grizzlies and other wildlife high on a mountain in Alaska. We have camera and sketching gear with us to capture these majestic animals for our future paintings. (photo by Bart Rulon)

BEAR
ANATOMY

Comparing the Frontal Views of Black, Grizzly and Polar Bears
The facial features of the black bear are relatively refined and delicate compared to those of the grizzly, which has a disk-shaped head with a more massive muzzle. The polar bear's muzzle seems the largest of the three bears, and its head seems small compared to the rest of its body. Whereas the eyes of black and grizzly bears are more centered on their faces, the polar bear's eyes are higher on its face. This is because the polar bear spends much of its time swimming in search of prey, often with just its eyes and nose above water.

All bear species have eyes that seem conspicuously small compared to the rest of their otherwise massive heads and bodies. Also, black and grizzly bears have eyes that seem too close together. It is important to remain true to the species when painting the eyes of the bear, rather than enlarging the eyes to a more pleasing size. It is worth noting that the apparent size of the bear's ears is related to the age of the bear. Because the ears of a bear do not grow in the same proportion as the bear's face, a younger bear appears to have large ears compared to an older bear. Therefore, when capturing the age of the bear in a painting, such as in a painting of a mother with her cubs, be sure to accurately portray the size of the ears.

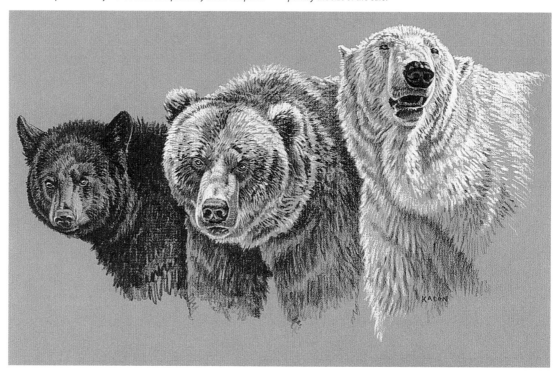

Side Views of Black, Grizzly and Polar Bears
With its fine, pointy features, the face of a black bear can often look like a large dog from the side. Also, one of the major distinguishing features between the side facial view of a black bear and a grizzly bear is the typically flat or convex angle of the black bear's muzzle as compared to the inward curve or concave shape of the grizzly's muzzle. In contrast, the muzzle of the polar bear appears longer and more pronounced. This is because the polar bear's eyes sit higher on its head and its ears are set farther back and slightly lower than those of the black and grizzly bears.

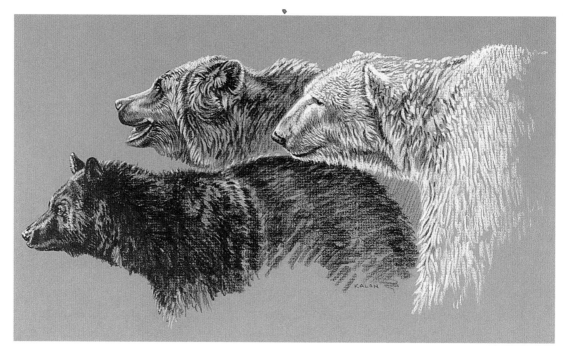

Grizzly Family Portrait

When painting the faces of grizzly bears, one must also recognize the differences in the facial features of bears when their age and sex are considered. The young bear on the right can be distinguished by a much decreased length and mass in the muzzle, as well as ears that appear much larger relative to the size of its head. Male grizzly bears, like the one shown in the middle of the drawing, tend to be larger than female grizzlies, and their overall appearance can seem more masculine with their heavier muzzle and body mass. The two grizzly bears pictured on the left are males of distinctly different ages—one at around 2½ years and the other at around 6½ years of age. You can see how much larger the head of the older bear is compared to the younger bear. More significantly, as bears age, one can tend to see the masculinity or femininity of the animal, whereas male and female bears look very similar in youth.

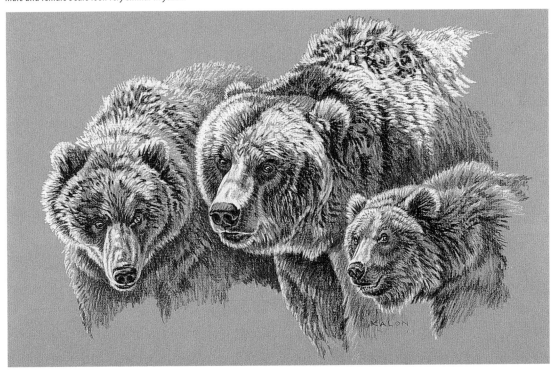

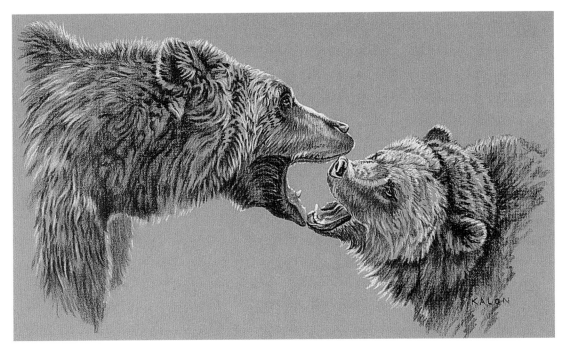

Grizzly Bears in Action

I've spent many hours observing bears in action, and I am amazed every time at how expressive their faces can be. For instance, the younger and older bears shown here engaged in a playful fight carry expressions of fierceness with their furrowed brows, upturned noses and open mouths.

Fur pattern radiates
outward from the eyes.

Note the almond-
shaped eyes.

Muzzle shows less
texture than the face.

Grizzly Bear Anatomy Close-Up

1 | GRIZZLY BEAR

Getting Started

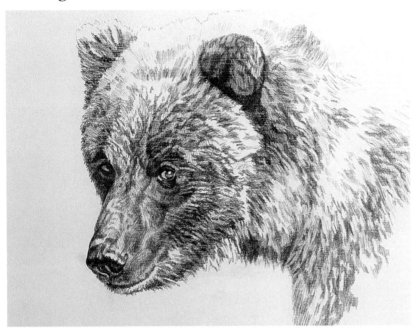

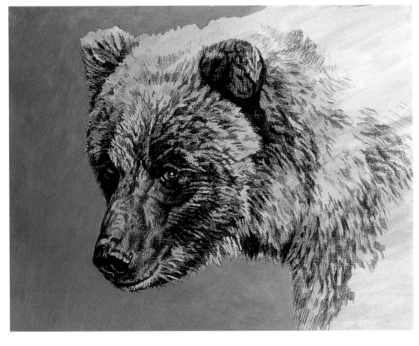

1 DRAWING ON GESSOED PANEL

Using a soft, graphite pencil, transfer your image onto the painting surface. When transferring the drawing, keep in mind the importance of your value scheme. Instead of just doing a line drawing, I like to do a complete value drawing as I feel this enhances the outcome of the painting. Your painting will be only as good as your drawing. Work out all of your anatomical features in the drawing, and you will be spared headaches later on in the painting process. It is also important in this stage to carefully place the image of the animal on the painting surface in a position that you will be happy with when the painting is finished. To avoid smudging the graphite drawing, spray it with a clear acrylic coating, such as Krylon Crystal Clear.

2 TINTED PAINTING SURFACE

Using a 1-inch (25mm) flat brush, apply a transparent wash to the painting surface to give a neutral background color; otherwise, you will be fighting against the starkness of the white background when applying your paint. Try to keep your background wash in the medium value range. This makes it easier to determine your lights and darks as you develop the painting. For this painting, I used a combination of Burnt Sienna, Naples Yellow and Titanium White diluted with Liquin, which I brushed on with a 1-inch (25mm) flat brush. Please make sure your paint-to-Liquin ratio is sufficient so that you have a transparent wash when going over your pencil drawing. It would be a shame to lose the details and hard work of your initial drawing.

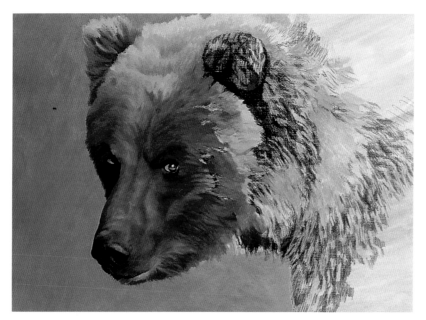

3 BEGINNING THE UNDERPAINTING

Begin blocking in the painting by putting down what will be your underpainting. Use a larger brush at this stage of the painting, as details are not of interest at this point. The main objective is to put in the shapes and shades that are the building blocks of your painting. Using a no. 10 or a no. 12 flat sable brush, block in your light values first. This way you don't muddy your lights with the darker values underneath. Then choose your warm, medium values and block them in. Warm colors include Naples Yellow, Cadmium Yellow, Cadmium Orange, Yellow Ochre, Raw Sienna, Burnt Sienna and Burnt Umber. When finished with this, add your cool, medium values, such as Alizarin Crimson, Ultramarine Blue and Cerulean Blue. Be careful of mixing your warm and cool hues together. You can end up with muddy, drab colors.

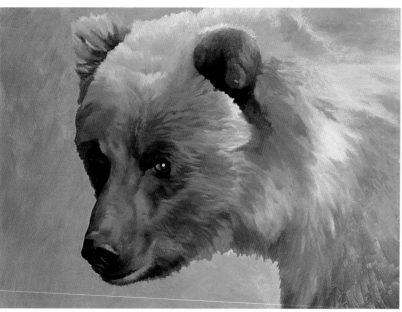

4 FINISHED UNDERPAINTING

Also important in the underpainting is the blocking in of the major shapes of the image. Your underpainting should have very distinct developed light and dark planes of color. Use your underlying value drawing to determine where to place the darks and lights in order to create the illusion of three-dimensional depth and mass. After developing this depth, you can begin refining the underpainting with both color and detail. Using a smaller brush, such as a no. 4 to no. 6 flat sable brush, go back into the underpainting and pick out your highlighted and shadowed areas, adding more vibrant colors and lighter and darker values. Oftentimes, fur on animals will reflect the colors that are in the sky. With this bear, Cerulean Blue mixed with Titanium White, Naples Yellow and a touch of Burnt Sienna, when applied around the eye and muzzle as a highlight, enhances the painting by adding a vibrant color that would normally occur in nature.

Muzzle

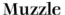

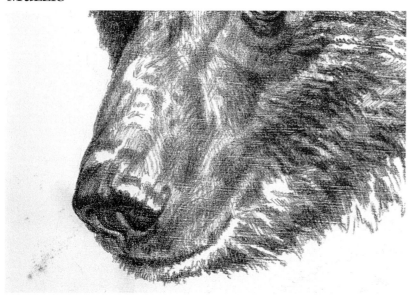

1 DRAWING ON GESSOED PANEL

This graphite drawing is of a three-quarter view of the muzzle of a grizzly. You can see all of the details included in the drawing, such as correct anatomy and the texture and shadows of the fur. Remember, as you apply the paint to this drawing, try to match the shades and values that you have established in the drawing.

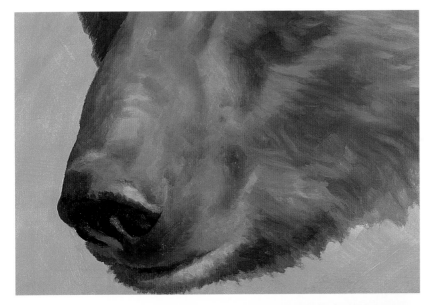

2 UNDERPAINTING

Now that you have done the underpainting of the grizzly's head, it is time to focus specifically on adding detail and dimension to each part of the face, starting with the muzzle. During this second phase of the underpainting process, make sure that your first underpainting is completely dry to avoid the muddiness that results from paints unintentionally mixing together. Pay close attention to the way in which the light is hitting the subject of your painting. It is crucial that you portray this lighting effectively in your painting. Notice that in this painting, the light source is coming from the right to the left in a downward angle. This is very important to keep in mind, as you can now begin to darken your shadowed areas and lighten the highlighted areas.

For the darkened areas, such as the front part of the nose and mouth and underneath the chin, use a no. 6 or no. 8 flat brush to work up the shadows. Use a mixture of Ultramarine Blue, Alizarin Crimson and a touch of Raw Umber to block in the front part of the nose. The other dark areas are warmer, so use a base of Burnt Umber with some Alizarin Crimson and a bit of Ultramarine Blue to create this warm, dark feel. Add a touch of Titanium White to the color mixtures to lighten them to the appropriate values. For the cool highlighted areas, mix Cerulean Blue, a touch of Ultramarine Blue, Alizarin Crimson, Raw Umber and a larger amount of Titanium White to obtain the shade and hue of the highlights. For the warm highlighted areas, replace the blues in the above mixture with Naples Yellow, Cadmium Yellow and Cadmium Orange. Remember in this stage of the painting, the highlights and shadows you create are less detailed and more subtle than those created in the next stage. Therefore, save your lightest lights and darkest darks for the next step.

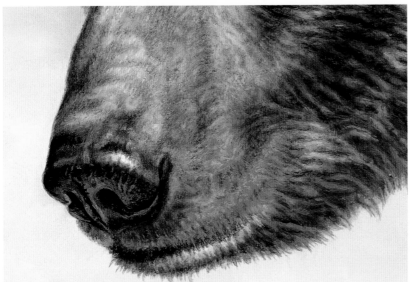

3 DRYBRUSHING

When the second underpainting is completely dry, apply a coat of Liquin and allow it to dry. This prepares the painting surface for the technique of *drybrushing*. Drybrushing involves loading a brush with just enough paint to rub on the painting surface—the more pressure you apply, the more opaque the layer will be. With less pressure, you will allow the underpainting to show through while enhancing the image with the overlying detail. This detail that you apply in the dry-brush process is much like the pencil value drawing with which you began the painting. However, this time, the underpainting will have all of the colors and most of your medium dark and medium light values in place. Now is the time to create the amount of texture and detail that you desire in your painting. This will transform your painting rather rapidly. All of the texture created on the muzzle, including the shorter hair on top of the muzzle, the longer hair on the

side of the muzzle, and the details of the nose, are created by drybrushing with just three dark colors. Raw Umber is the primary color to use. For warmer textured areas, add Burnt Umber, and for the cooler areas, including your darkest blacks, add Ultramarine Blue.

For the final step in painting the muzzle, make your highlights pop out by using Titanium White on the areas that reflect the most light, such as the wet spot on top of the nose. For the warmer highlights, add a warm color to the white, such as Naples Yellow. Apply this warm highlight to the individual hairs that catch the most sun. Adding a cool color to the white, such as Ultramarine Blue, allows you to highlight such cool areas as the shadowed side of the nose and the individual hairs in shadow around the mouth and the muzzle. You will be amazed at the textures you can create by using this technique.

Eyes

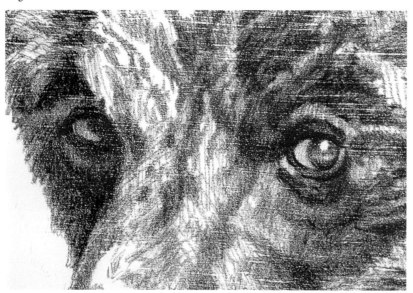

1 DRAWING ON GESSOED PANEL
Notice the texture and details incorporated in the underdrawing, as well as the accuracy of the shape and placement of the eyes.

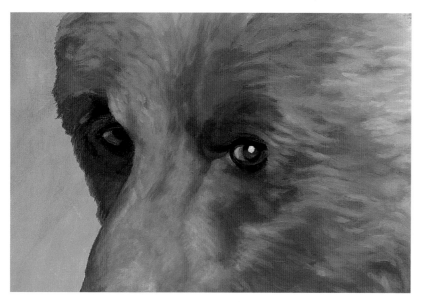

2 BEGINNING THE UNDERPAINTING
Using the drawing as a guide, block in the major areas around the eyes using your middle values. You can begin to show some texture in the fur around the eyes; however, keep these textures in the middle ranges, as you will develop them further later. Most of the colors in the fur around the eyes are similar to those used in the fur on the muzzle. Note the blue highlights around the eyes, as they portray the reflection of the sky and add color to the painting.

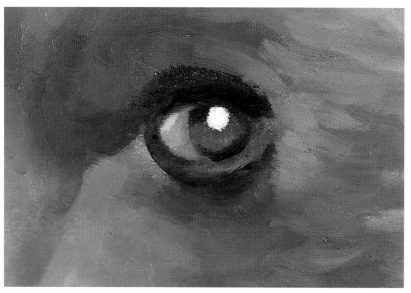

3 REFINING THE UNDERPAINTING
To begin the process of blocking in the eye, darken the area on top of the eye, which is in shadow, and begin to create the eyelid that surrounds it. Then paint in the iris and the whites of the eye. For the iris, I used a mixture of Burnt Sienna, Titanium White and a touch of Cadmium Orange. Remember that the whitest part of the eye will be the reflection from the sun. Keep the whites of the eyes duller than what the reflection will be. Use a no. 2 flat and a no. 2 round brush to work up the details of the eyes.

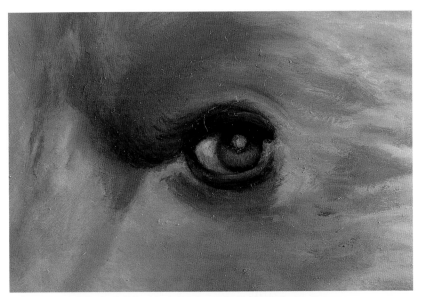

4 DETAILING THE EYES

Further refinement of the underpainting of the eyes involves adding the pupil and adding darker and lighter shades to the entire eye area. For the pupil, you will want to develop the color using Burnt Sienna and a touch of Titanium White. When adding the pupils, make sure that they are lined up with one another in such a way that the bear appears to be looking in the direction you desire, as it is easy to make the mistake of creating a cross-eyed or walleyed bear.

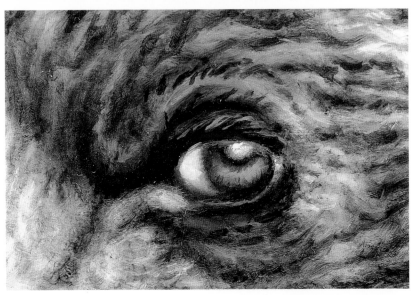

5 DRYBRUSHING

This is where you will add your darkest darks and lightest lights by using the dry-brush technique. After allowing the paint and the clear coat of Liquin to dry, drybrush in the details around and in the eye using a no. 1 round and a no. 2 flat sable brush. The eyes allow you to create a variety of expression in the bear's face. For instance, by turning and showing the whites of the eyes and furrowing the brows, I created an expression of interest in my direction. When adding the final touch to the reflection of light in the eye, note that although it may be the brightest spot of the painting, it is still not pure white. Rather, add a touch of Ultramarine Blue to the Titanium White to show that it is reflecting the color of the sky.

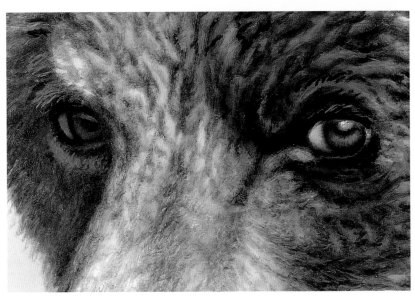

6 INTEGRATING THE EYES

Remember to integrate the eyes into the painting as a whole. Check to make sure that the colors in the fur surrounding the eyes corresponds with the fur on the rest of the face. Integrate the fur pattern into that of the face, noting that the fur seems to radiate from the eyes outward in a specific pattern. Also note that in this painting one eye catches the light and the other is in shadow. This adds interest to the painting, but you must keep in mind that each eye will be treated differently. Because things in shadow tend to call for less detail, leave the eye in shadow in its basic forms. That is, the iris and the white of the eye should be simplified in this eye.

Ears

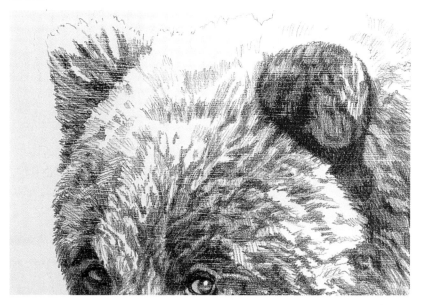

1 DRAWING ON GESSOED PANEL

When drawing the ears, notice that the ears of grizzly bears are very blunt and rounded as compared to those of other mammals. Again, remember to make sure that the ears are accurately proportioned and placed on the head during the drawing stage. Also, compare my initial drawing of the ears to the finished ears and notice how similar they are in detail and value. This means that your drawing should have as much detail as you plan to have in the final painting.

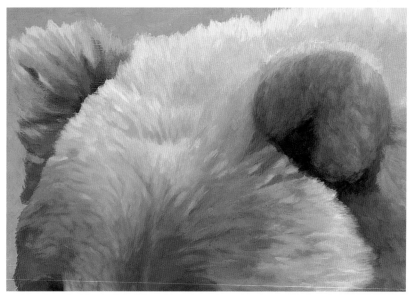

2 BEGINNING THE UNDERPAINTING

You can see that the ear on the right is primarily in shadow except for the highlight on top. In contrast, the ear on the left has more texture. In the shadowed areas, the primary cool colors used were a combination of Cerulean Blue, Ultramarine Blue and Alizarin Crimson, mixed with a small amount of Titanium White. You will also notice that there are some warm colors in this overall cool, shadowed area. These warm areas consist primarily of Burnt Sienna blended into the cool colors above. Use a combination of Titanium White, Naples Yellow and a touch of Cadmium Yellow for the highlights. I used a no. 10 flat brush to block in the larger planes of color around the ears, such as the forehead and the back of the head. I primarily used warm colors in these areas as they are receiving the most light from the light source. For the ears, I used a no. 6 filbert brush for the details and a no. 4 and no. 6 flat brush for roughing in the shapes.

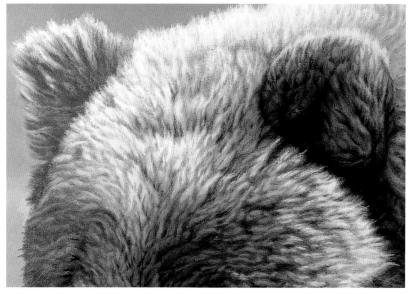

3 DETAIL OF THE FINISHED EARS

Begin to re-create in the painting the textures from the original drawing by using a no. 4 flat red sable brush and the aforementioned dry-brush technique. For the darkest areas, use a combination of Ultramarine Blue and Raw Umber, such as the area in dark shadow in the middle of the ear. For the warmer areas, such as those more affected by the light source, you will use more Burnt Umber than Ultramarine Blue. As in your pencil drawing, you are creating a value drawing over your underpainting. The best way to think of this is that you are painting in the negative space. In other words, rather than painting the hairs, you are painting the shadows around the hairs. As usual, the last step is to add in the highlights by loading up your brush with your warmest and lightest colors and actually paint in the hairs that receive the most light.

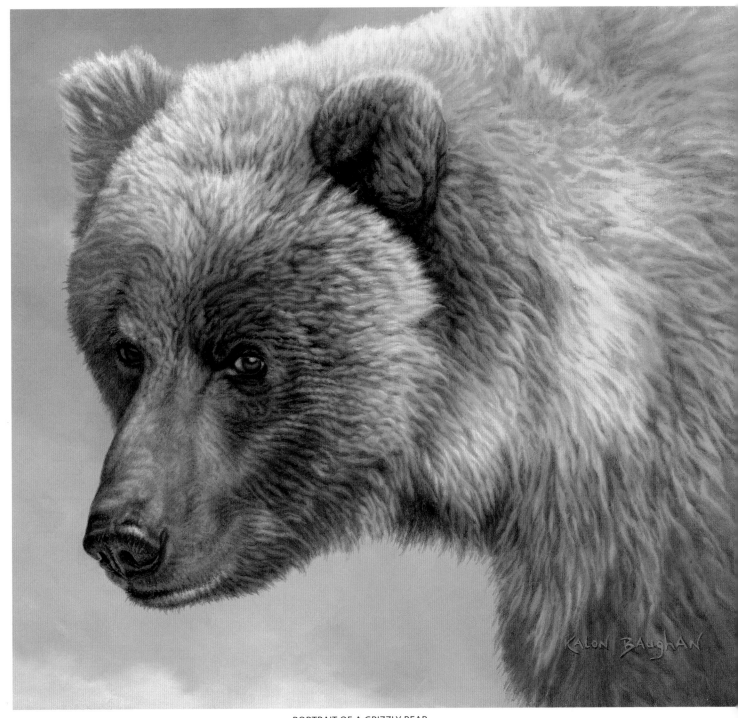

PORTRAIT OF A GRIZZLY BEAR
Kalon Baughan, oil on panel, 15" x 18" (38cm x 46cm), collection of Charlie and Peggy Casper

Comments on the Finished Painting

Now that you have completed all of the individual elements of the painting, step back from the painting and see if these components come together and work as a whole. There are two tricks that I use to help in this process. One is to turn the painting upside down and look at it, and the other is to look at it through a mirror. Both of these techniques allow you to look at your painting in a completely different way. I find that I lose my objectivity after working on a painting for a long time, and using these techniques helps me to see the painting from a fresh perspective. For example, upon looking at this painting from this different perspective, I found that I had to push the value range in the painting by making the darker areas darker and the lighter areas lighter. This was very easy to do by using wash techniques. For the lighter areas, I added a wash of white or yellow to the areas receiving the most light. And to the darker areas, such as the area around the eyes, my favorite colors to use in the wash are Ultramarine Blue and Raw Umber. For the background, I used a blend of neutral colors that were harmonious with the colors in the bear. I chose to leave the background muted so as not to compete with the bear. Overall, I feel that this painting portrays the intriguing nature of the grizzly bear that I encountered in Alaska.

WOLVES

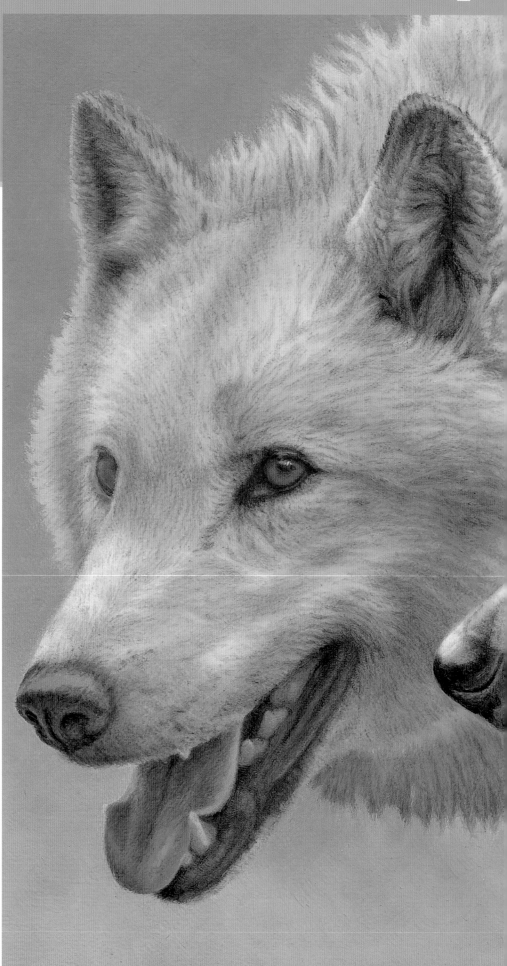

erhaps the most loved and the most hated animal of North America is the wolf. The wolf is loved for many reasons. Most obvious is its kinship with one of our most revered pets, the dog. In fact, it is said that all dogs are descendants of wolves. Wolves are also loved because they are truly the spirit of the wild. At the same time that wolves are loved for being wild, they are also feared for this quality. Historically, myths persisted of wolves killing children and hunters, and in modern society, wolves are hated by some for killing ranchers' livestock. However, whether you love or fear wolves, their beauty is undeniable, which is why they are perhaps the most frequently painted animal in wildlife art today.

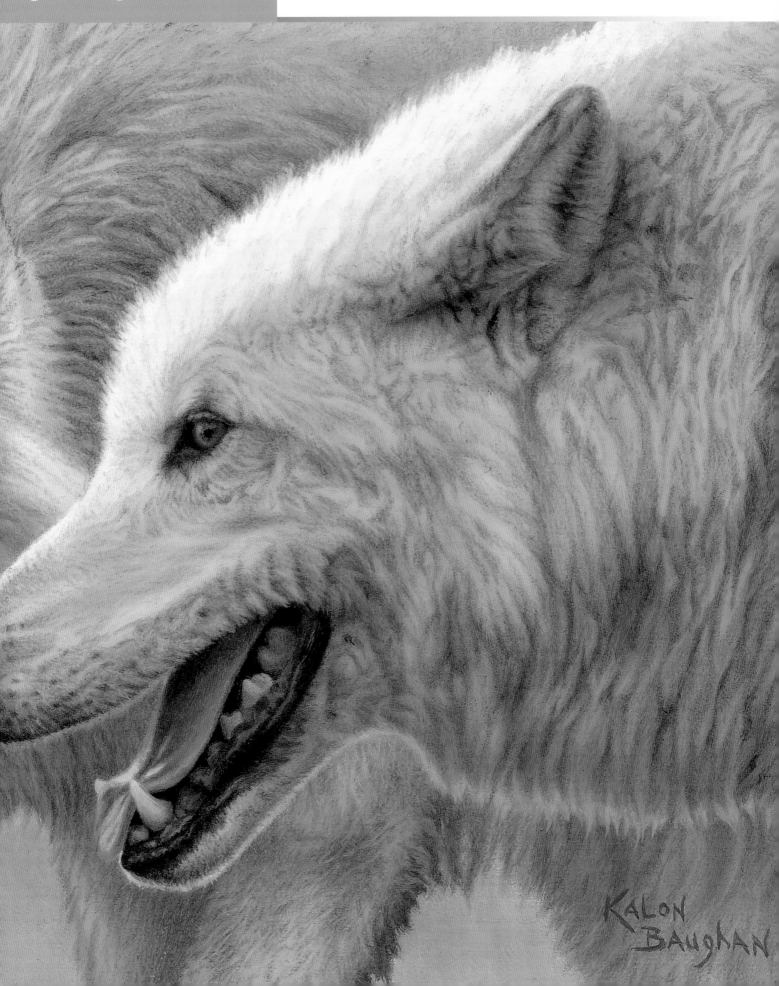

KALON
BAUGHAN

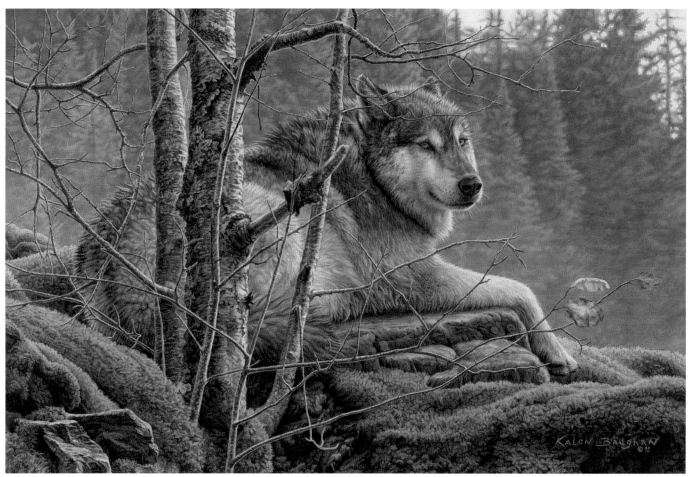

FACE TO FACE
Kalon Baughan, oil on canvas, 16" x 24" (41cm x 61cm), collection of Dr. Benjamin and Jaque Johnson

In this painting I wanted to capture the thoughtful and contemplative nature of the wolf.

There are four distinct types of wolves on this continent: the gray wolf, the arctic wolf, the red wolf and the Mexican wolf. In this chapter, we will be talking specifically about the gray wolf and the arctic wolf, which are the two most prevalent types of wolves in North America. The main difference between the arctic wolf and the gray wolf, besides the different regions they live in, is their color and size. Because it lives in an area of intense cold that is often covered by snow, the arctic wolf is larger and always white. The white coat acts as camouflage in the snow, while the larger body size gives the animal greater mass for retaining body heat. The gray wolf, on the other hand, is generally smaller in size and can be a variety of different colors, ranging from all black to all white, but mostly having a reddish-gray color with a white underbelly.

Only one-fifth of the original range of the wolf population currently exists. However, there is a new movement in the United States to bring the wolf back to some of its original habitat, such as

in Yellowstone National Park. The gray wolf can be found in the northern regions of the lower forty-eight states, from Michigan westward. They are plentiful in Canada and Alaska. Perhaps the best place to see gray wolves in the lower forty-eight states is Yellowstone National Park, where they have recently been reintroduced. I have been fortunate enough to see wild gray wolves, both in Yellowstone and in Denali National Park in Alaska.

Arctic wolves, as their name implies, live in the high Arctic regions and are much more difficult to see in the wild because of the remoteness and rugged nature of the areas they inhabit. This brings up a valuable point about getting good reference material of animals in enclosures. Although I've been able to watch gray wolves interact in the wild, through a spotting scope, I've never been able to get good reference photography of them in the wild. Likewise, I've never seen an arctic wolf in the wild at this point in my career. However, because I still believe that it is important to get your own refer-

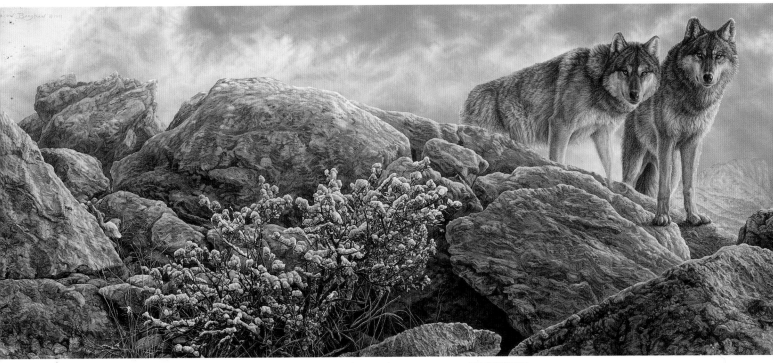

ENCOUNTER
Kalon Baughan, oil on canvas, 18" x 42" (46cm x 107cm), collection of
Warren and Nina Maurer

*While canoeing a river in northern Wisconsin, I realized that on the op-
posite shore there was a wolf trotting at about the same speed I was
canoeing. I quietly eased the canoe closer and closer to the shore that
the wolf was on. At one point, the wolf turned directly toward the river
and noticed my presence. I remained motionless and drifted down the
river while the wolf and I maintained our eye contact. This encounter
left an indelible image in my mind, which inspired the emotion in this
painting.*

ence material for your paintings, I have had to
resort to photographing wolves in zoos and
wildlife reserves for my wolf paintings.

The wolf seems to be the archetypal image in
wildlife art. Like many others, I am drawn to the
wolf, both spiritually and artistically. Spiritually,
I'm drawn to the Native American lore surround-
ing the importance of the wolf. I'm intrigued by
the intelligence of these animals, including their
ability to socialize in a pack and rear young as a
group. I am also impressed by their heartiness,
as they are survivors of brutality by humans as
well as some of the harshest climates on earth.

Artistically, I am drawn to capturing the intel-
ligence and character in their facial expressions,
including the intensity of their gaze. All in all,
wolves are one of my favorite animals to paint
because of their powerful symbolism and their
sheer beauty.

WOLF ANATOMY

Here is a pack of gray wolves and a pack of arctic wolves with their heads shown in various positions, including frontal, three-quarter, side and back views.

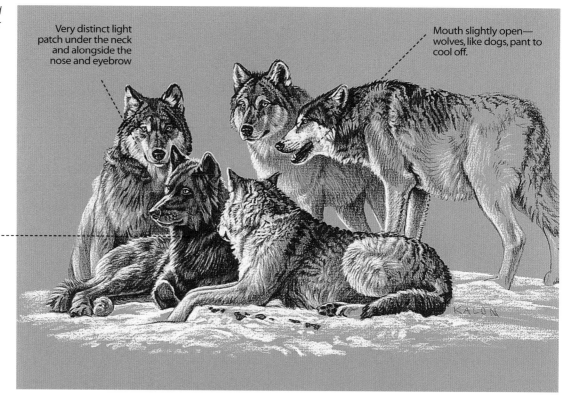

Very distinct light patch under the neck and alongside the nose and eyebrow

Mouth slightly open—wolves, like dogs, pant to cool off.

Black color phase of the gray wolf

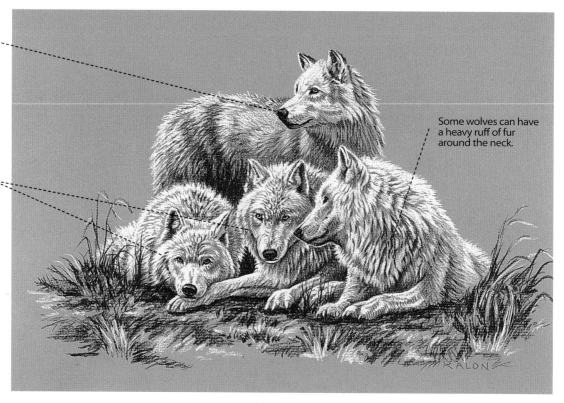

Dark nose and eyes stand out against the all-white fur of the arctic wolf.

Some wolves can have a heavy ruff of fur around the neck.

Frontal views, one with head tilted up and one tilted down

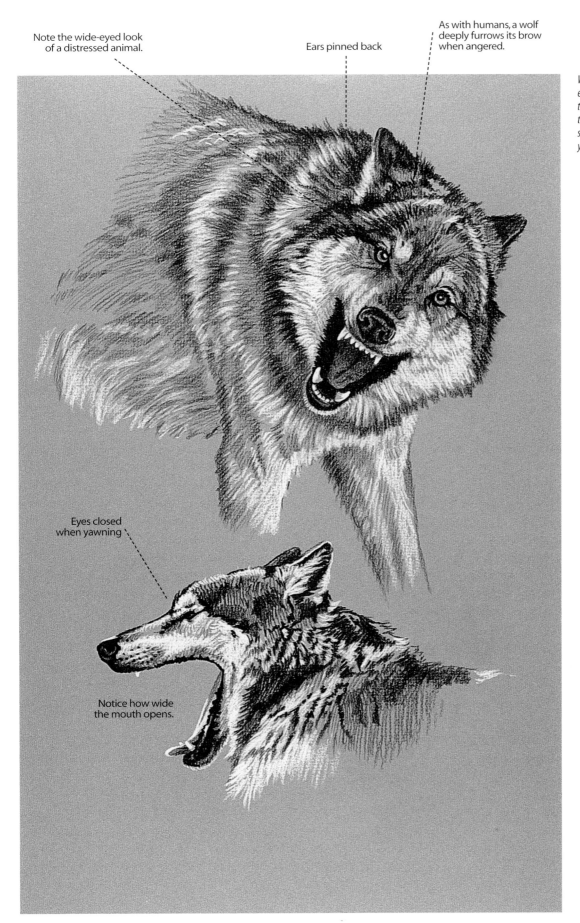

Note the wide-eyed look of a distressed animal.

Ears pinned back

As with humans, a wolf deeply furrows its brow when angered.

Wolves can have a wide range of expressions—from one of intense anger, as shown above in the snarling gray wolf, to one of sleepiness, as in the wide, gaping yawn of the wolf below.

Eyes closed when yawning

Notice how wide the mouth opens.

2 | ARCTIC WOLVES

Getting Started

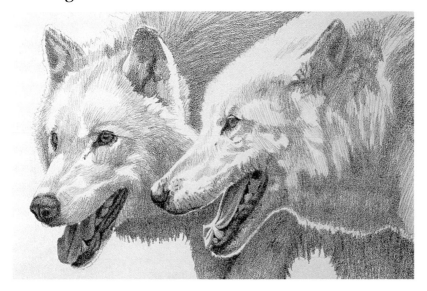

1 DRAWING ON GESSOED PANEL

An accurate drawing of the wolf anatomy will greatly aid in the development of the painting. Spray a fixative over the drawing so that the graphite won't smear when beginning the painting process.

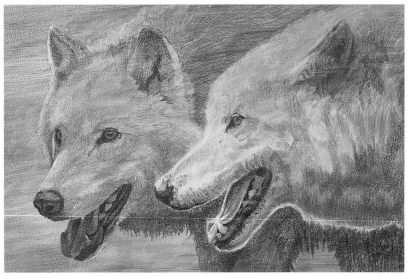

2 TINTED PAINTING SURFACE

I used a grayer tinted wash, made from a mixture of Payne's Gray diluted with oil medium, because the predominant color scheme of this painting is in grays.

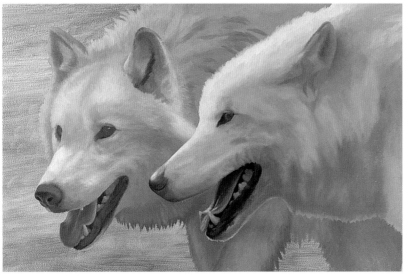

3 THE FINISHED UNDERPAINTING

Because there is so much gray in this painting, I mixed up several different hues of warm and cool gray by mixing complementary colors, such as combinations of Viridian and Alizarin Crimson, Cadmium Orange and Ultramarine Violet, and Cadmium Red Deep and Manganese Blue. Paler grays can be created by adding Titanium White to the mixtures above. The other predominant colors that I used in the underpainting were Naples Yellow for the warmer areas of the fur, Burnt Sienna in the eyes and Cadmium Red, Cadmium Orange, Cadmium Yellow and Ultramarine Blue for the tongue, nose and muzzle area. The usual assortment of brushes was used for the underpainting, from a no. 10 to a no. 3 flat brush.

Eyes

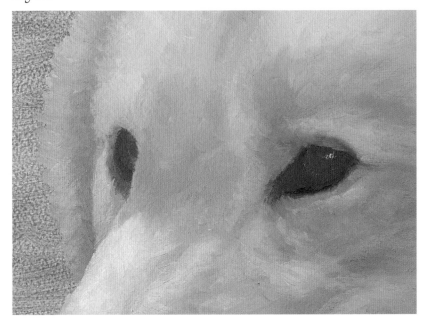

1 UNDERPAINTING

The iris is comprised primarily of Burnt Sienna, with a dash of Cadmium Yellow and Titanium White. The dark area around the eye is a dark, cool gray mixed from the complementary colors Viridian and Alizarin Crimson, with a dash of Ultramarine Blue. The fur around the eyes has different variations of gray, all muted with Titanium White or warmed up with Naples Yellow.

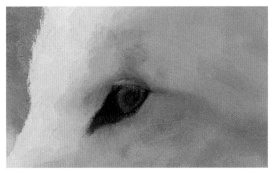

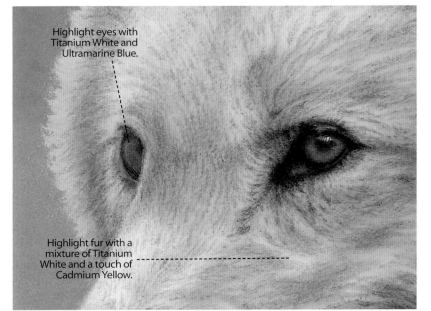

Highlight eyes with Titanium White and Ultramarine Blue.

Highlight fur with a mixture of Titanium White and a touch of Cadmium Yellow.

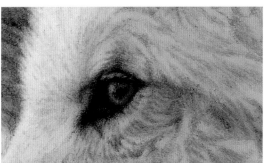

2 DETAILS OF THE FINISHED EYES

I used drybrushing to darken the pupil and the dark area around the eyes, as well as to create the texture in the fur. I further enhanced the color of the eyes with a wash made from Cadmium Orange, Cadmium Yellow and a touch of Titanium White diluted with oil medium.

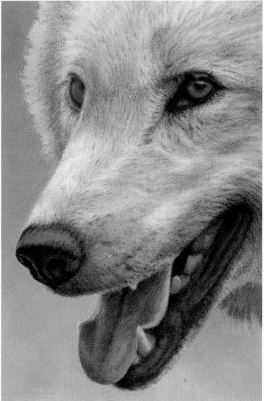

Eyes and Muzzle
Form Expression
The majority of an animal's personality and expression comes from the manner in which the eyes and muzzle are painted in conjunction with one another.

Muzzle

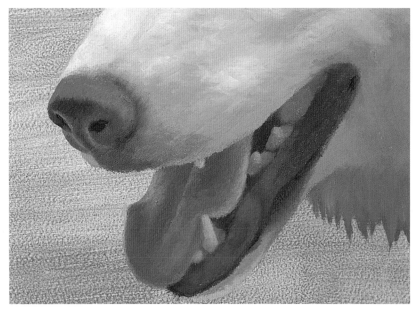

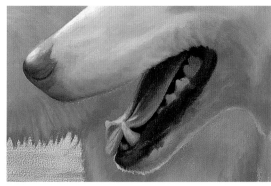

1 UNDERPAINTING

The most variety of colors used in this painting is in the area of the muzzle. These include combinations of Cadmium Yellow, Cadmium Orange, Cadmium Red, Burnt Sienna, Alizarin Crimson and Ultramarine Blue, along with various hues of gray. All of these colors were dulled down with Titanium White or Naples Yellow. The colors in the wolf on the left are cooler in comparison to the wolf on the right. This creates a subtle sense of atmospheric perspective between the two wolves. Because the wolf on the right is closer to the viewer, the colors will be warmer and more intense.

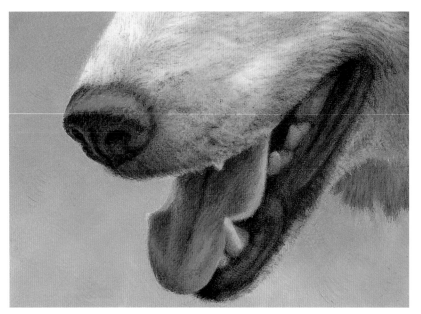

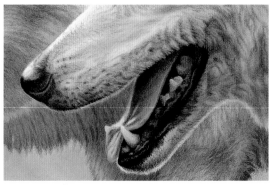

2 DETAILS OF THE FINISHED MUZZLE

Using the dry-brush technique, create the details and textures around the darker areas of the lip and nose and the areas of the tongue that are in shadow. There is also a great deal of texture in the fur around the muzzle, for which drybrushing can be very effective. Highlight the various areas of the muzzle with Titanium White, creating a wet texture on top of the nose and tongue. Using Titanium White with Cadmium Yellow and Cadmium Orange, create a backlit effect on the wolf on the right by painting the undersides of the upper and lower muzzle with this mixture.

Ears

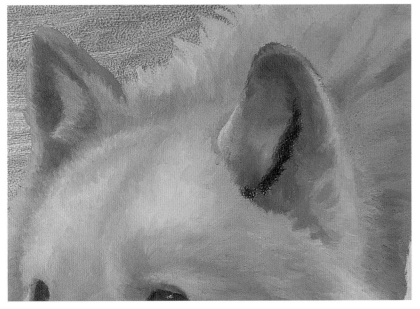

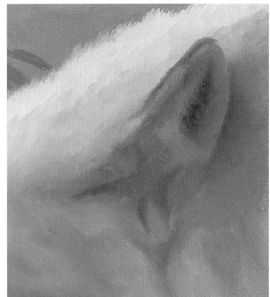

1 UNDERPAINTING

The areas in shadow around the ears should be painted with cooler and darker hues of gray, while the edges of the ears and the top of the forehead are warmer grays highlighted with Titanium White, Naples Yellow and Cadmium Orange.

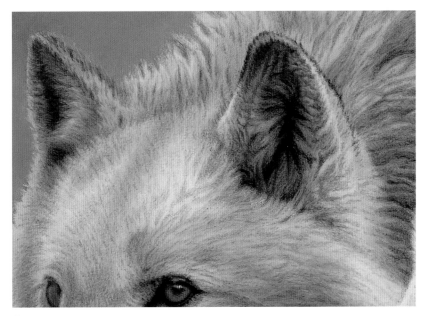

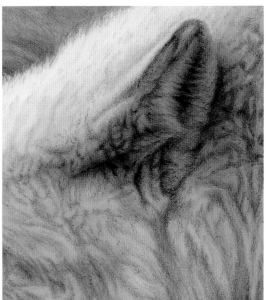

2 DETAILS OF THE FINISHED EARS

Create the texture of the soft fur inside and around the ear by using the dry-brush technique. Highlight appropriately with lighter warm and cool colors.

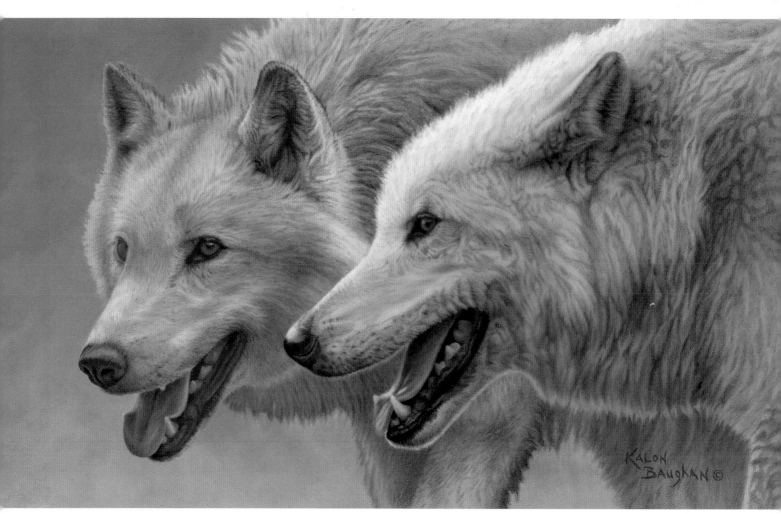

ARCTIC WOLVES
Kalon Baughan, oil on panel, 10" x 16" (25cm x 41cm),
collection of Mr. and Mrs. Folgham

Comments on the Finished Painting

The energy in a painting can be greatly enhanced by having more than one animal interacting in the image. I've had many people say that their main attraction to some of my paintings is the interplay between the animals. This painting successfully portrays the two wolves in conjunction with one another because of the aforementioned use of warm and cool colors to create distance between the wolves. It is also important to capture the accurate size of the wolves in relation to one another, as well as to create a composition that enhances the dynamics of the duo.

3 | GRAY WOLF

Getting Started

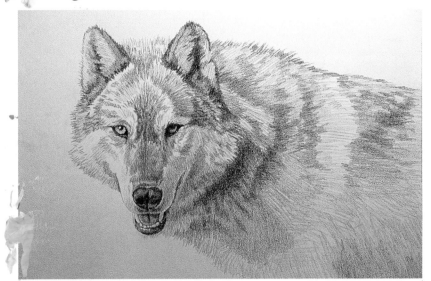

1 DRAWING ON GESSOED PANEL

Compositionally, the most important element of this painting is the visual encounter you have with the wolf. Naturally, the eyes are the first part of the painting to which your eyes are drawn, so I chose to place the eyes left of center to avoid a bull's-eye composition. Remember to apply a fixative to your drawing before tinting the painting surface so as to prevent your drawing from smearing.

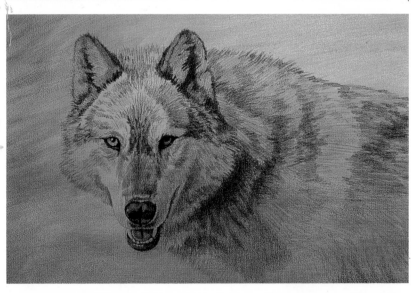

2 TINTED PAINTING SURFACE

Use a wash of Burnt Sienna to tint the panel. This color will subtly come through to create an overall tone of warmth in the finished painting.

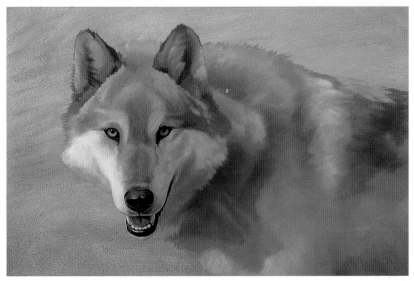

3 FINISHED UNDERPAINTING

As in the painting of the arctic wolves, premix several hues of gray to use as your base colors. For warmer grays, use a combination of Cadmium Lemon and Permanent Mauve; and for cooler grays, use mixtures of Viridian and Alizarin Crimson or Permanent Green Light and Winsor Violet (Dioxazine). For some of the more orange-gray sections of the underpainting, use a combination of Cadmium Orange and Ultramarine Violet. Remember that all of these grays have been dulled down with Titanium White.

Eyes

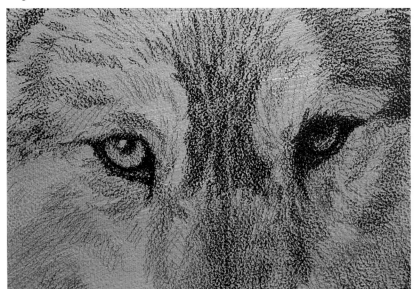

1 TINTED DRAWING

Again, remember to put down enough detail in the drawing to help you develop your painting, but not so much that you waste time on a stage of the process that will be covered with paint.

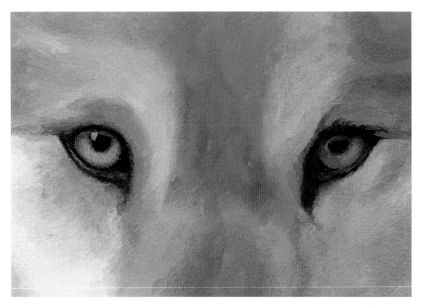

2 UNDERPAINTING

Using a small brush (e.g., no. 4 flat), apply a mixture of Lemon Yellow, Cadmium Yellow, Cadmium Orange and Titanium White to the iris, using a touch of Burnt Sienna along the edge. The eye on the left is getting more sunlight than the eye on the right, so darken the iris colors on the right eye with a touch of Ultramarine Blue and Raw Umber. For the dark areas around the eye and in the pupil, mix a dark black color with Ultramarine Blue and Raw Umber. Where light reflects off of the eyelid and for the catchlight in the pupil, add a small amount of Titanium White. While using the aforementioned combinations of grays for the underpainting of the fur around the eyes, you can also use Cadmium Orange and Naples Yellow to warm up the area directly between and above the eyes.

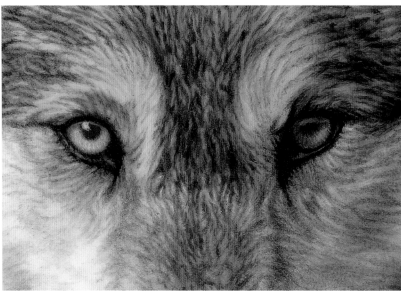

3 DETAIL OF THE FINISHED EYES

What most people really respond to in this painting is the direct eye contact that the wolf is making with the viewer. To create this intense stare, put extra effort into developing the eyes. Add subtle highlights to the iris, using a mixture of Titanium White and Cadmium Yellow, and further darken the pupil and eyelids by using the dry-brush technique and a combination of Burnt Umber, Raw Umber and Ultramarine. All of the fur texture surrounding the eye is also done with the dry-brush technique using these same colors. The final stage in developing the fur is to add highlights using Titanium White and Naples Yellow to the lightest parts of the fur. All of the details in the eyes can be done using your three smallest brushes.

Muzzle

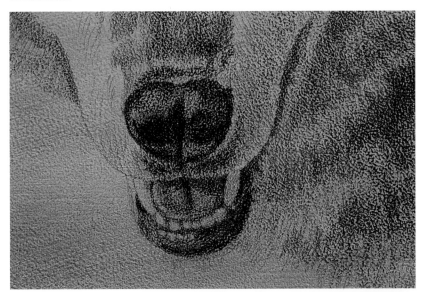

1 DETAIL OF THE TINTED DRAWING

Getting the anatomy of the muzzle worked out in your drawing is important, for it will be much more difficult to fix later in the painting process.

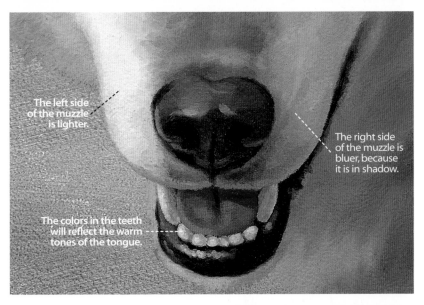

The left side of the muzzle is lighter.

The right side of the muzzle is bluer, because it is in shadow.

The colors in the teeth will reflect the warm tones of the tongue.

2 UNDERPAINTING

The specific colors used in the tongue are Cadmium Red, Cadmium Orange, Cadmium Yellow and Titanium White. The teeth are a mixture of Titanium White, Cadmium Yellow, Cadmium Orange and a touch of Ultramarine Blue. Think of each tooth as a cone shape, having a light source on one side and a shadow on the other. Like the nose, tongue and lips of the wolf, the teeth have a highly reflective surface, so highlights are important here. The nose and lips of the wolf are much darker than the rest of the muzzle, which can be achieved by mixing Ultramarine Blue and Raw Umber into your palette. Remember, use smaller brushes when detailing the muzzle.

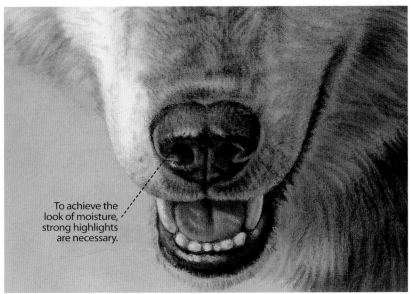

To achieve the look of moisture, strong highlights are necessary.

3 FINISHED MUZZLE

By using Burnt Umber and Raw Umber in the dry-brush technique, you can develop all of the textures in the fur around the muzzle. In the darkest areas, such as the nose, lip and shadowed areas around the teeth and tongue, you will want to add Ultramarine Blue to the dry-brush colors. The last step is to redefine or enhance the reflective light on the shiny surfaces of the muzzle. For the nose and lip, highlight with a mixture of Titanium White and Ultramarine Blue, and for the tongue and teeth, use warmer highlights, such as Titanium White, Naples Yellow, Cadmium Yellow and Cadmium Orange.

Ears

1 TINTED DRAWING

Notice how the texture in the drawing corresponds to the textures in the finished painting. Even though it is eventually covered with paint, I really do rely on the underdrawing to develop my textures.

2 UNDERPAINTING

The ears of the gray wolf tend to be a warmer gray. For this, add Cadmium Orange and Burnt Sienna to your grays. In the darker areas, use a combination of Ultramarine Blue and Raw Umber in your grays.

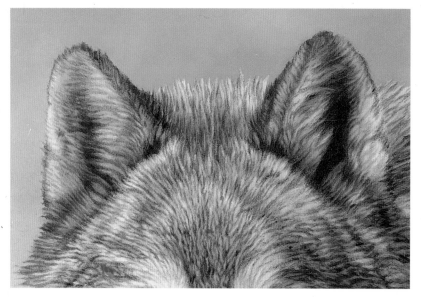

3 DETAIL OF THE FINISHED EARS

Using the dry-brush technique, develop the rich textures of the ears and surrounding forehead. Light-colored paint added after drybrushing creates effective highlights, such as on the wispy hairs inside the ears and the highlights on the top of the head and in front of the ears. Notice how the left ear is casting a shadow, so the forehead should be darkened. Also, darken the inside areas of the ears using Ultramarine Blue and Raw Umber.

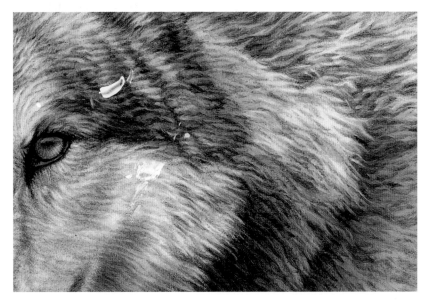

The fur of the gray wolf is a combination of short fur, as on the muzzle and head, and longer fur, such as in the ruff of the neck. When painting fur you will be attempting to create an illusion. Rather than painting each individual hair, drybrushing can be used to paint blocks of negative space between the clumps of fur. When creating the illusion of shorter fur, the dry-brush stroke is shorter and choppier, with a more fluid stroke for the longer fur. Also remember that natural-looking fur should be painted in various directions and patterns, rather than in straight lines. Gray wolf fur is also broken up into several large patterns of color, including the pure white fur of the eyebrows, the neck and the side of the muzzle. However, the majority of the wolf's fur is comprised of a grayish, salt-and-pepper color.

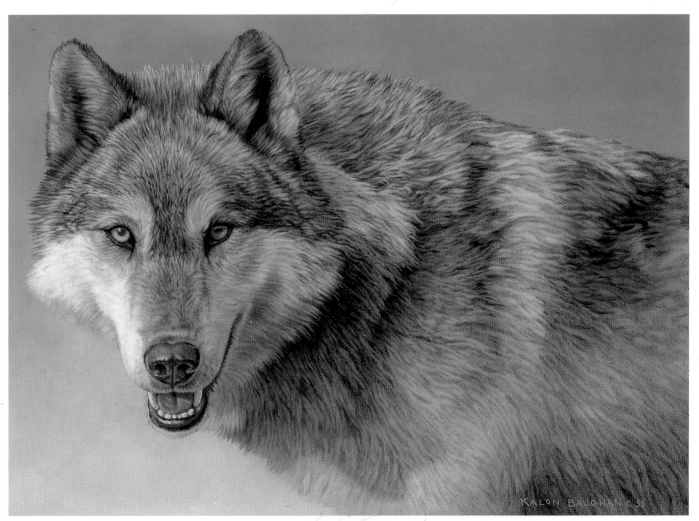

PORTRAIT OF A GRAY WOLF
Kalon Baughan, oil on panel, 12" x 18" (30cm x 46cm), collection of Dr. Bill and Gay Campbell

Comments on the Finished Painting

I feel that the most effective aspect of this painting is the intense gaze of the wolf. There is nothing quite as compelling as a wolf staring directly into your eyes. This creates a visual connection with the viewer of the painting, giving the sense of a true interaction with the animal. Also, the subtle interplay of light, such as in the shadow of the muzzle on the wolf's chest, not only helps create an illusion of three-dimensionality, but helps the viewer feel the warmth of the sunlight on the wolf's fur.

CATS

ust as wolves are loved for their connection to dogs, the big cats of North America hold a special place in our hearts as close relatives of the domestic cat. When observing and painting wild cats, I am continually amazed at how similar their features, facial expressions, body movements and behaviors are to the barn cats that I grew up around on my family farm. Personally, wild cats are my favorite subject matter to paint, primarily because whether they are relaxing, playfully interacting with other cats or hunting, their facial expressions seem to convey intellect and intense emotions that I find captivating to capture on canvas.

KALON
DAUGHAN

If you can't go out into the wild to research wild cats, you can always use a house cat as subject matter for your feline paintings.

Domestic cats have similarly shaped eyes, ears and muzzles as their wild counterparts, but with a more compact profile and smaller nose.

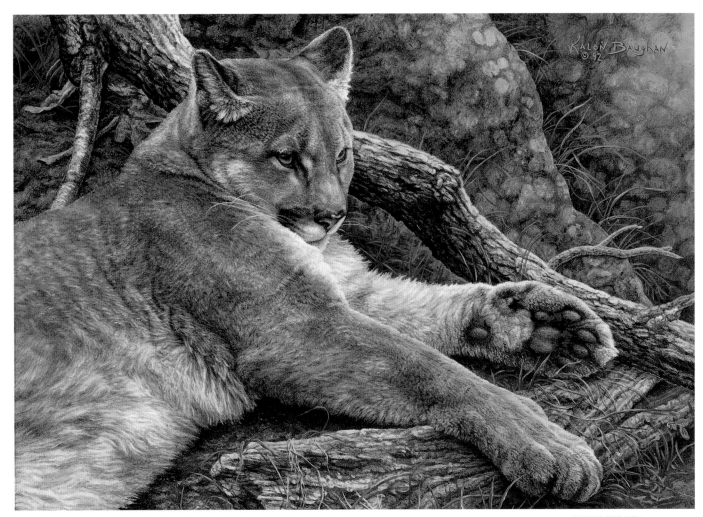

SILENT REPOSE
Kalon Baughan, oil on canvas,
11" x 15" (28cm x 38cm), private
collector, Canada

*The look of a reclining cougar is
remarkably similar to that of a
resting house cat.*

There are several wild cats that inhabit the United States. The three most commonly sighted cats are the bobcat, lynx and cougar, with other cats, including the elusive jaguar, making rare appearances. Although the bobcat and the lynx are beautiful and intriguing animals, in this chapter I will focus on the two largest cats: the cougar and the jaguar. Cougars, also known as panthers, mountain lions, catamounts, painters, pumas or American lions, range from the southern tip of South America to the Canadian Yukon. In the U.S., the cougar is most readily found in the West and in very small numbers in Florida. However, because cougars are stealthy, private animals and often use their surrounding habitat as cover, they are difficult to view in the wild. I personally have seen only four cougars in the wild, despite spending a great deal of time in cougar habitat.

Jaguars originally roamed much of the Southwest, but they were pushed out of the U.S., primarily by hunters and concerned ranchers. Recently, however, they have migrated back into their original habitat, mainly because they are less likely to be killed, as people have developed a greater appreciation of their presence. Like cougars, jaguars are difficult to observe in nature. Therefore, your best bet at obtaining reference material of these majestic cats is to visit your local zoo or private game farms where professional handlers may make these and other animals accessible to you for a price.

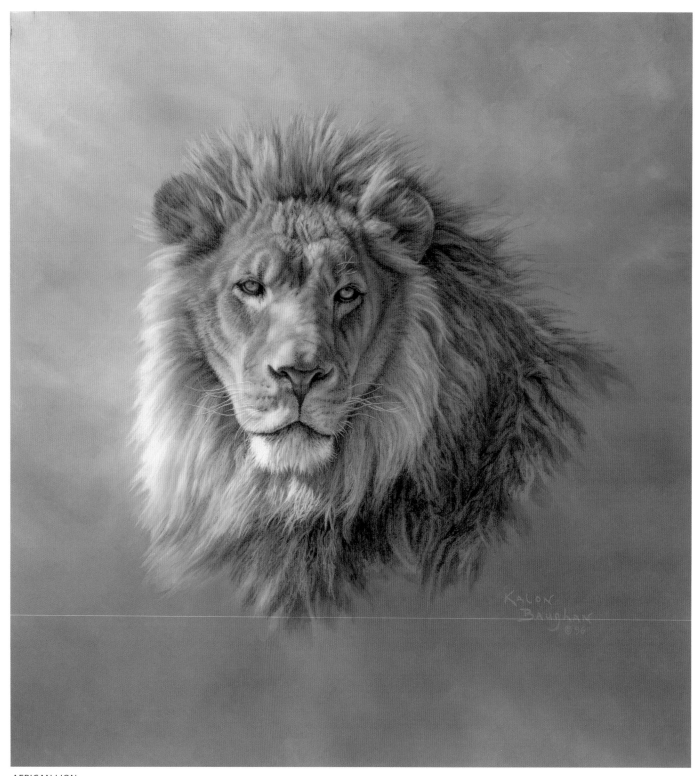

AFRICAN LION
Kalon Baughan, oil on canvas,
15" x 14" (38cm x 36cm), collection of Craig and Wendy Lyon

The mane of the male African lion helps give it the regal appearance for which it is renowned.

There are far too many species of wild cats around the world to discuss here. However, I would like to mention three of my favorites: the snow leopard, the African lion and the Bengal tiger. The snow leopard, one of the few cats that inhabits extremely cold, high-altitude regions, is found primarily in the Himalayas. Its coloring is thus beautifully camouflaged for hunting in snowy habitats. In contrast, the African lion,

with its sandy coat, is suited to its dry, arid environment. An interesting side note about the lion is that it is known to live in social groups, or prides. The Bengal tiger once inhabited a wide range of Asia and Russia but is now extremely endangered. It is one of the most striking wild cats with its unique fur pattern and its daunting presence.

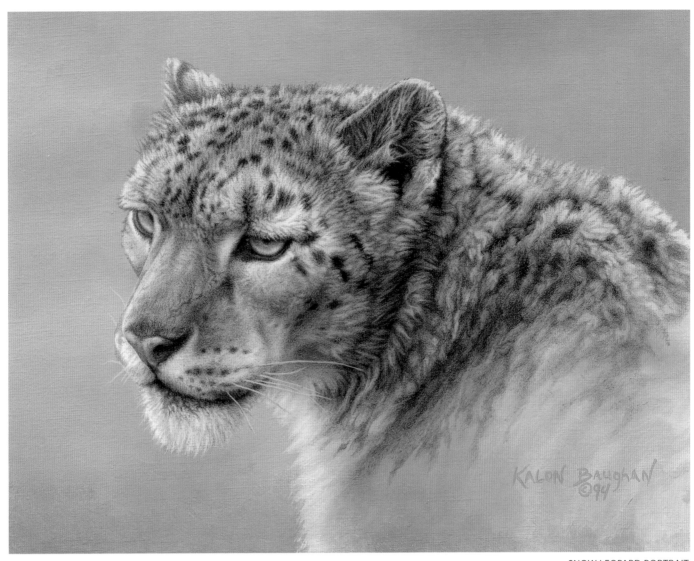

SNOW LEOPARD PORTRAIT
Kalon Baughan, oil on canvas,
8" x 12" (20cm x 30cm), collection
of Robert and Margie Sheeley

Note the distinct
light and dark pattern.

Longer fur
around the jowls

Bengal Tiger

COMPARISON
OF THE COUGAR AND THE JAGUAR

A cougar's head is more angular.

A jaguar's ears are more rounded and stubby.

Note the round shape of the jaguar's head.

The jaguar's head and muzzle are heavier and more massive.

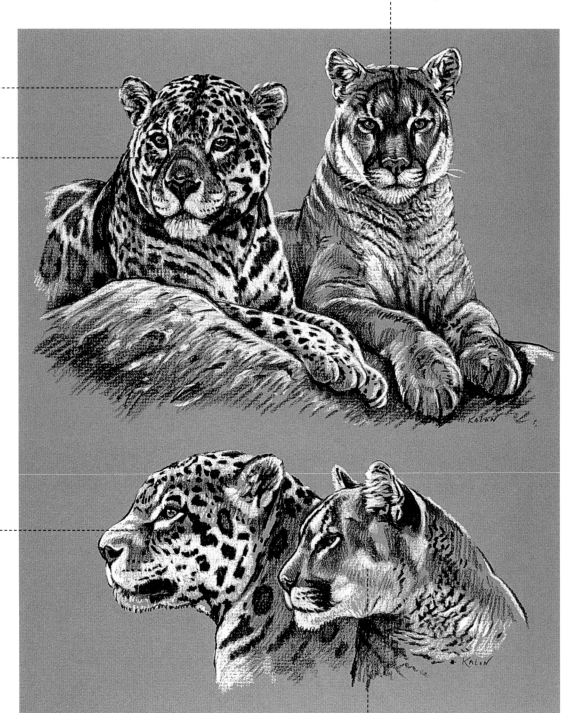

The most obvious difference between the cougar and the jaguar is the distinctive pattern of the jaguar's coat. Cougars tend to be a solid, tawny shade. Jaguars, on the other hand, tend to be a yellowish-orange color, with a white belly and a unique pattern of solid black spots on the face that open up into black circles filled with orange as the fur extends to the body.

The cougar's features are more delicate.

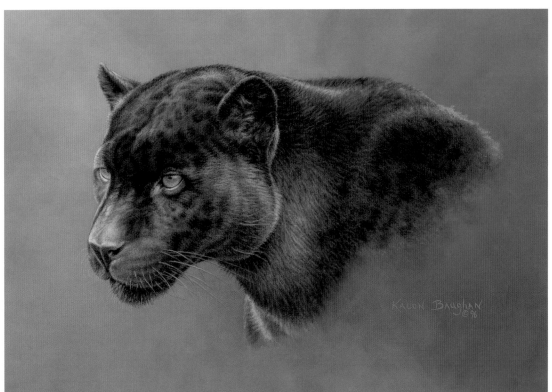

BLACK JAGUAR
Kalon Baughan, oil on canvas,
9" x 15"(23cm x 38cm), collection
of Robert and Kathy Swanson

Occasionally, the fur of a jaguar can appear to be solid black. These animals, commonly known as black panthers, actually do have black spots that can be seen upon closer inspection. In contrast, there has never been a confirmed sighting of a black cougar.

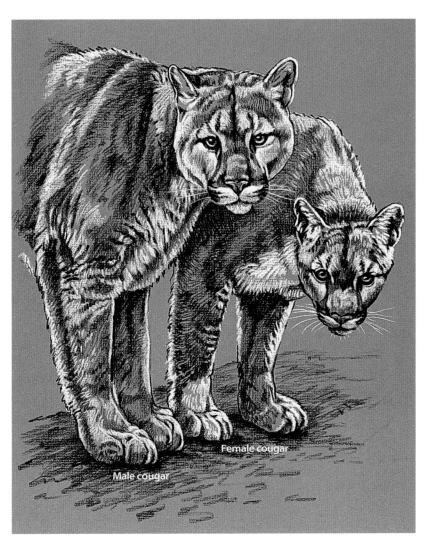

Male cougar

Female cougar

Both the cougar and the jaguar are very large in size, with adult cougars ranging from ninety to two hundred pounds. In both cat species, the males tend to be larger than the females, particularly in terms of the size of their heads. Males tend to have more masculine facial features that also distinguish them from females.

4 | COUGAR IN ITS HABITAT

Getting Started

1 DRAWING ON GESSOED PANEL

When laying out the composition for a painting that involves more of the animal's body and a background, it is important to plan ahead for the placement of the main focal point, which in this case is the head of the cougar. Again, you should refrain from placing the focal point of your painting in the center of the composition, which is why I placed the head in the upper right-hand corner. Furthermore, creating a diagonal across the painting surface with the animal's body enhances the interest level of the composition. Placing the feet of the cat at the other end of the diagonal creates a visual balance with the head. Finally, the fact that the cougar is gazing outside of rather than into the painting creates a visual tension, as it is not what the viewer of the painting expects to see.

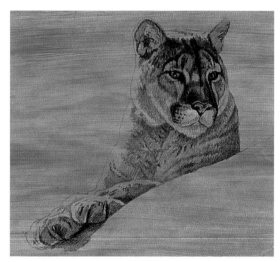

This cat has the classic male cougar head. It is angular and massive, with masculine features.

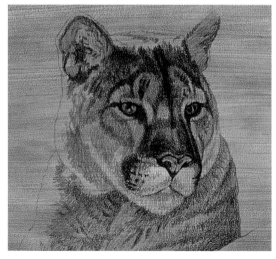

2 TINTED PAINTING SURFACE

For the wash on this painting, I used a mix of Burnt Sienna, Payne's Gray and painting medium.

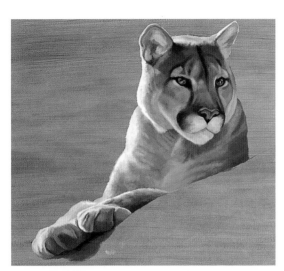

3 FINISHED UNDERPAINTING

I primarily used three grays for this painting, each having their own unique hue. The first is a warm gray composed of Cadmium Lemon and Permanent Mauve. The second is a cool gray that is a mixture of Viridian and Alizarin Crimson. And the third is an orange gray, made up of Cadmium Orange and Ultramarine Violet. All of these grays can be lightened and dulled down with Titanium White. The other main colors that I used were Raw Sienna, Cadmium Yellow, Cadmium Orange and Titanium White. I used a no. 10 and a no. 6 flat brush to block in the major shapes of the underpainting and a no. 3 flat brush for the details.

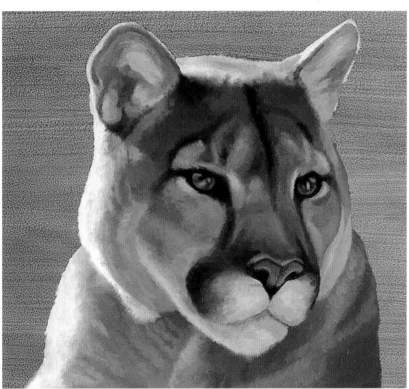

Eyes

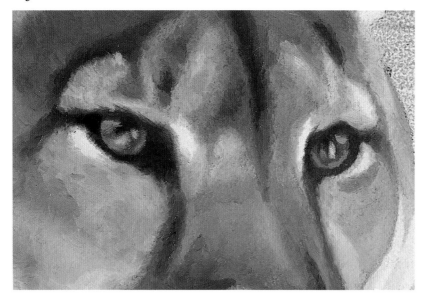

1 UNDERPAINTING

For the underpainting of the eyes, I used the Viridian–Alizarin Crimson gray on the cooler or bluer areas of the fur around the eyes and in the iris. I used the Cadmium Lemon–Permanent Mauve gray mixed occasionally with Raw Sienna, Cadmium Yellow and Cadmium Orange for the warmer areas, including those in the iris. The darker areas, such as the eyelid and the vertical line on the forehead, are a mixture of Burnt Umber and Raw Umber. I used a no. 3 and a no. 5 flat brush for these areas, while being careful not to mix the cooler with the warmer colors.

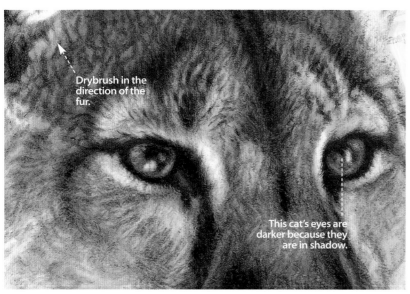

Drybrush in the direction of the fur.

This cat's eyes are darker because they are in shadow.

2 DETAIL OF THE FINISHED EYES

First, use the dry-brush technique to darken all of your darks and to create the various textures in the fur surrounding the eyes. After the dry-brushed areas are dry, go back into the iris with Permanent Green on a no. 1 round brush and very carefully dab in some color, as cougars tend to have a brownish-green hue to their eyes. Also, using lighter values and a no. 1 round brush, touch up the highlights, including the light spots in the eyes.

Ears

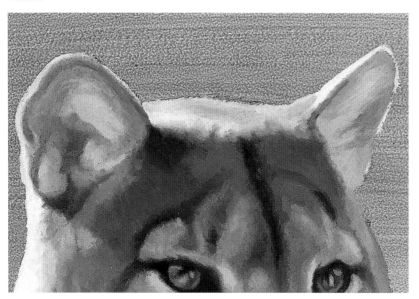

1 UNDERPAINTING

Note the strong backlighting of the ears and the side and top of the head. Use Titanium White and a touch of Cadmium Yellow to create the effect of light hitting these areas. The pinkish color in the ear is created by using a combination of Cadmium Red and Cadmium Orange mixed with Titanium White. The rest of the areas in the ear are gray tones heavily saturated with Titanium White.

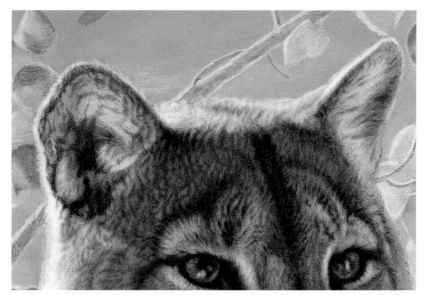

2 DETAIL OF THE FINISHED EARS
Using the dry-brush technique, develop the texture in the fur around the ears. To create the mottled look of the inside of the ear, darken the area that is most in shadow in the center of the ear with Raw Umber. Also use Raw Umber to create the irregular spots in the ear. For the wispy, lighter hairs, use softer dry-brush strokes, laying down less paint. Develop the rim of the ear with irregular, darker strokes, being careful not to boldly outline the rim.

Muzzle

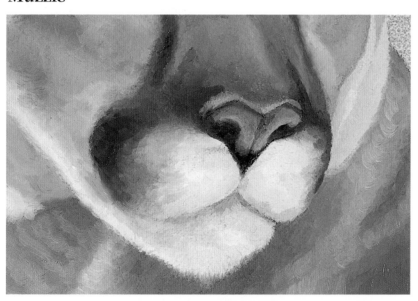

1 UNDERPAINTING
The lighter areas in the muzzle are comprised of very muted shades of gray mixed with Titanium White and a touch of Cadmium Yellow and Cadmium Orange. The orange color in the nose is predominately Cadmium Orange, with a touch of Cadmium Red, Burnt Sienna, Cadmium Yellow and Titanium White. The darker areas around the muzzle are Burnt Umber mixed with various shades of gray. I mainly used a no. 8 and no. 6 flat brush for the muzzle, getting down to a no. 3 flat brush to detail the nose. To prevent your colors from getting muddy, avoid mixing your warm and cool tones.

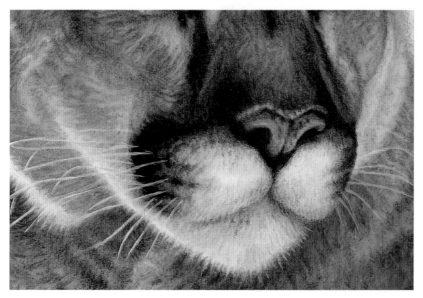

2 DETAIL OF THE FINISHED MUZZLE
Use combinations of Burnt Umber and Raw Umber to dry-brush the textures of the fur over the underpainting. On the nose, drybrush irregular marks to give the cat's nose character. Finally, add the whiskers and the highlights on the jowls by using a no. 1 round brush with a dab of Titanium White and Cadmium Yellow, adding a light blue-gray on the whiskers that are in shadow.

Integrating the Portrait Into the Complete Painting

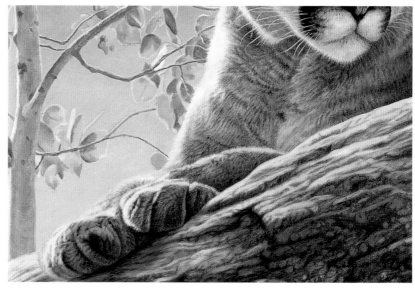

At times you may want to include part of the animal's body in a painting that is still primarily a portrait. It is important that the fur tones and textures flow from the head to the body. After spending a great deal of time developing the face of the animal, you must also put the same amount of quality into the rest of the body.

When adding the foreground and background, the integration of the animal into its surroundings is critical. Often the animal will reflect in its coat the colors of its encompassing environment, or vice versa. This is called reflective light, and when captured effectively, it can greatly enhance the overall appeal of the image. Elements of a background can often be exaggerated in terms of their atmospheric perspective. In other words, less detail and slightly more muted colors, as in the aspen tree behind the cougar, help the cat stand out against the background.

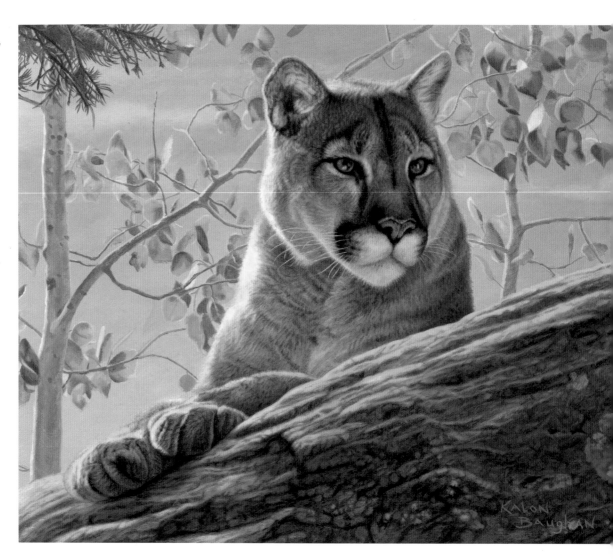

FRONT RANGE COUGAR
detail, Kalon Baughan, oil on panel,
12" x 18" (30cm x 46cm),
collection of Dr. Robert and
Rita Augsburger

Comments on the Finished Painting
The intense backlighting in this image creates a strong sense of three-dimensionality and warmth. The lyrical branches of the aspen and the bright colors of the leaves soften the masculinity of the painting, in contrast to the solid mass of rock on which the male cougar rests. A strength of this painting is the integration of trees and rocks indigenous to this animal's habitat. This is key to a successful portrayal of nature.

5 | JAGUAR

Getting Started

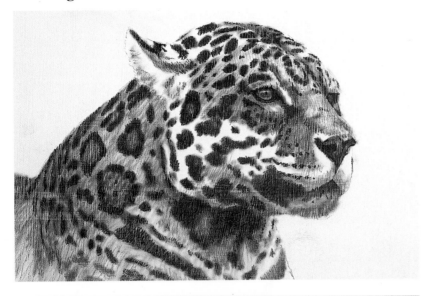

1 DRAWING ON GESSOED PANEL

The reference photograph of this jaguar was taken at a zoo in Toronto. This jaguar is in a three-quarter view with his ears drawn back, as if he has been disturbed by something. The look on his face also gives the impression that his attention has been drawn to something outside of the painting's range. Use a cotton swab to smudge and soften the drawing surface. Remember to spray fixative over the drawing to prevent smearing.

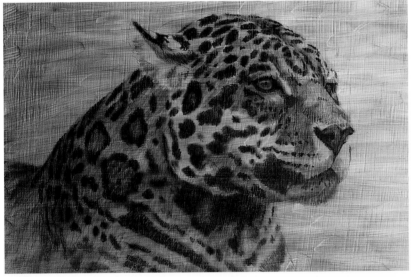

2 TINTED PAINTING SURFACE

I used Burnt Sienna thinned down with Liquin painting medium to create the wash for this painting.

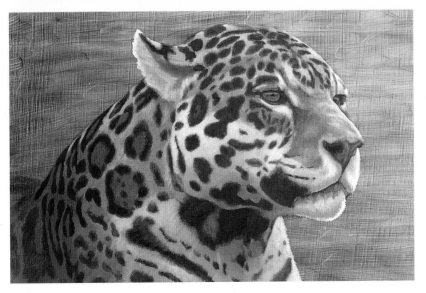

3 FINISHED UNDERPAINTING

The whitish areas of the jaguar, including the ear, muzzle and chest, are a bluish light gray created by mixing Cadmium Red Deep and Manganese Blue, lightened with Titanium White and an occasional touch of Naples Yellow. The yellowish-orange areas were blocked in with a combination of colors including Naples Yellow, Raw Sienna, Burnt Sienna, a touch of Cadmium Yellow and a gray made from Cadmium Lemon and Permanent Mauve. Block in these large areas with a no. 8 and no. 6 flat brush. Using a no. 4 and no. 6 flat brush, block in the main colors of the cat; then, while still painting wet-into-wet, lay in the details of the jaguar's pattern. The dark spots consist of a mixture of Raw Umber, Titanium White and a touch of Ultramarine Blue.

Eyes

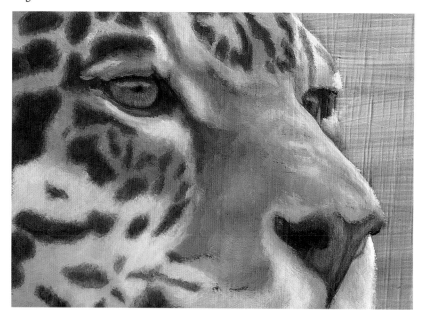

1 UNDERPAINTING

The colors used in painting the iris are comprised of a warm tone on the bottom made of Burnt Sienna and Cadmium Orange, blended into a mixture of Permanent Green with a touch of Ultramarine Blue lightened with Titanium White. Above the pupil, there is a dull gray line representing the surrounding light that the eye is reflecting. The darker areas of the eyes consist of Raw Umber and Ultramarine Blue, with the lightest parts dulled with Titanium White. Use a no. 2 flat brush for the underpainting of the details of the eyes.

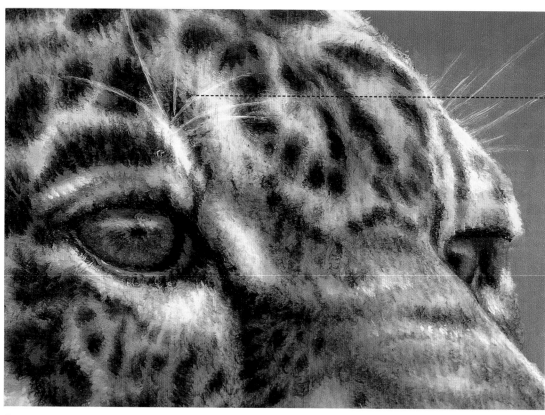

Use a cool, light color and a no. 1 round brush to paint the whiskers above the eyes.

2 DETAIL OF THE FINISHED EYES

Using the dry-brush technique, mix Raw Umber and Burnt Umber and detail the darker areas, such as the pupil and the dark area surrounding the eyes. The catch-light above the pupil isn't very bright because there isn't any direct sunlight hitting it. Load a no. 1 round brush with light gray paint and make a convex stroke above the pupil. Use the same gray paint to create the line of reflected light on the cat's bottom eyelid.

Muzzle

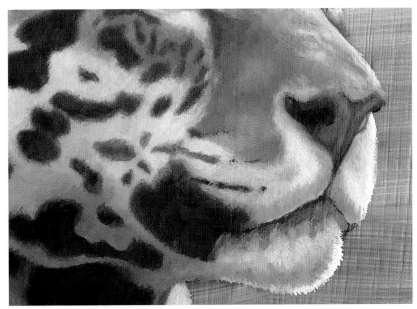

1 UNDERPAINTING

When painting the underpainting of the jaguar's nose, use a no. 2 flat brush to block in the orange areas. The darker areas in the nose and the surrounding muzzle consist of Raw Umber, Ultramarine Blue and Titanium White. Remember to block in the whitish areas of the muzzle first and then the orange areas, only adding the details at the end. Use the color mixtures and brushes described above in the section on the complete underpainting.

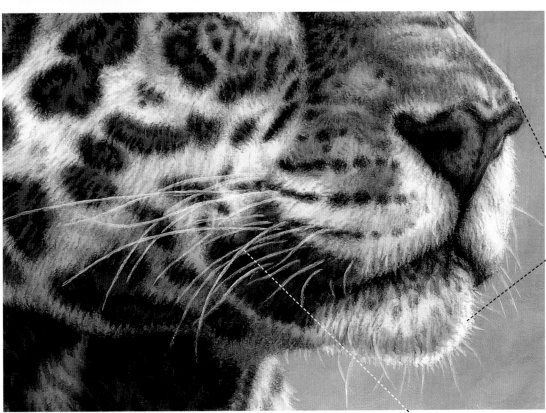

Subtle white line on top of the nose and under the chin indicates ambient backlighting.

A light gray mixture is used to paint the whiskers.

2 DETAIL OF THE FINISHED MUZZLE

With a mixture of Raw Umber and Burnt Umber and a no. 1 round brush, use the dry-brush technique to develop the texture and patterns of the fur on the muzzle. The small black spots on the orangish part of the muzzle that were not painted in the underpainting can now be added using drybrushing.

Ears

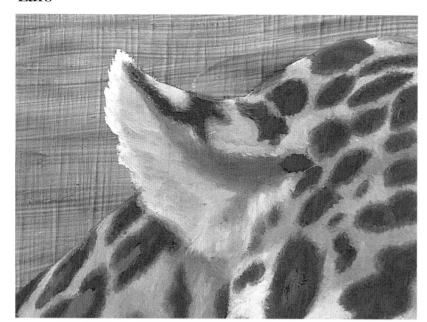

1 UNDERPAINTING

Using a no. 4 brush, block in the lightest colors first, being careful not to mix your warm and cool colors. Next, add the pattern on the ear and the surrounding area. Subtly blend the edges so that the pattern is integrated into the rest of the fur. The lightest area of the ear is at the very edge, indicating a subtle backlighting source.

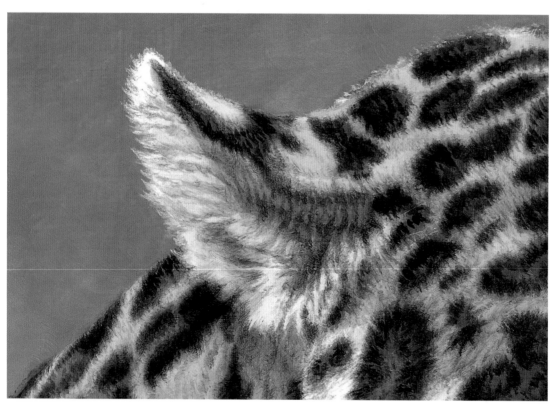

2 DETAIL OF THE FINISHED EARS

Using a combination of Raw Umber and Burnt Umber, drybrush the texture of the fur into the ear and surrounding area. Remember that the direction of your painting stroke should coincide with the direction of the fur. Also, reinforce the patterned area of the ear with darker colors such as Raw Umber with a touch of Ultramarine Blue.

Painting Fur Patterns

1 UNDERPAINTING

There are two main types of pattern in the jaguar's fur: solid dark spots, which sometimes connect to make unusual shapes, and dark rings filled with an orange color that is darker than the surrounding coat. Add all of the pattern once the entire underpainting is complete. The trick here is to subtly blend the edges of the pattern into the surrounding painting. Note that the dark areas in the underpainting are not pure black; rather, they are a very dark gray color. This is so that you can drybrush fur texture into these areas later.

2 DETAIL OF THE FINISHED FUR PATTERN

Using a combination of Raw Umber and Burnt Umber and a no. 1 brush, drybrush the fur texture into the patterned areas. Add Ultramarine Blue to the umbers only where you want very dark shades. Note that the darkest area of the pattern is not a solid dark color; rather, this is the point at which you should drybrush in the illusion of fur. Painting patterns on the fur can also help create three-dimensionality in your painting. As you can see here along the back of the neck and under the jowl, the roundish forms of the jaguar's spots become more elliptical as they spread toward the edge of the animal. When you capture this transition in the spotting, you will create a greater sense of depth and form in your painting.

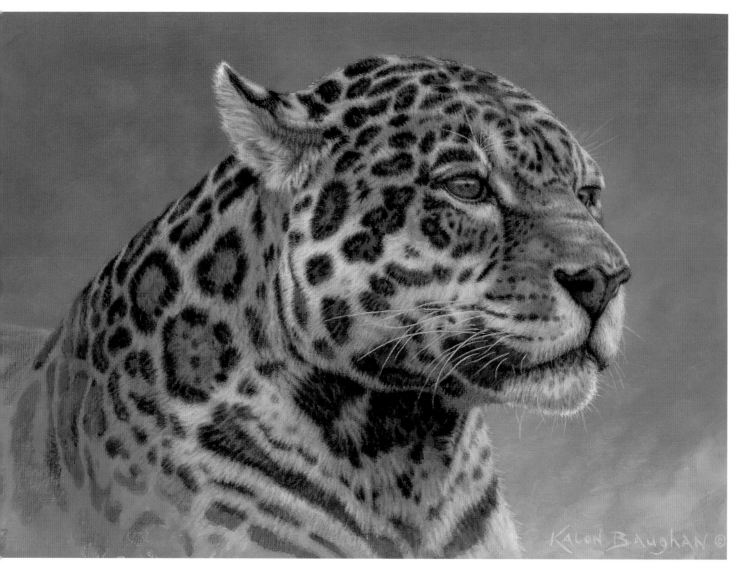

JAGUAR PORTRAIT
Kalon Baughan, oil on panel, 8" x 12" (20cm x 30cm), collection of
Dr. Robert and Rita Augsburger

Comments on the Finished Painting

The intensity of the jaguar's stare generates much of the energy in this painting and captures the essence of the individual animal. To finish the painting, I decided not to paint the details of the pattern all of the way to the edge of the painting. Instead, I subtly indicated the animal's shape and pattern by allowing the image to blend off. I also chose analogous colors for the background to create a harmonious interplay with the colors of the cat. The warm and cool grays are similar to those used in the underpainting of the cat. I also painted the background in a very thin layer to allow the Burnt Sienna of the wash to show through. I particularly enjoyed painting this jaguar and found the patterns of the fur to be captivating subject matter.

6 | COUGAR PORTRAIT

Getting Started

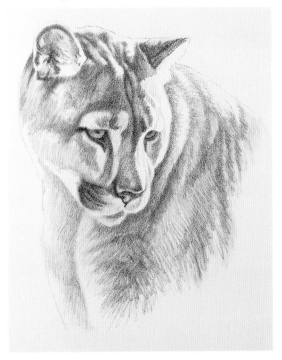

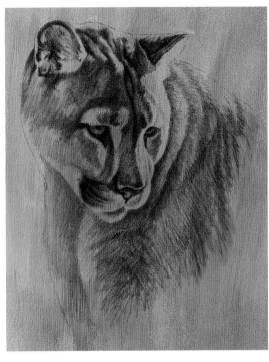

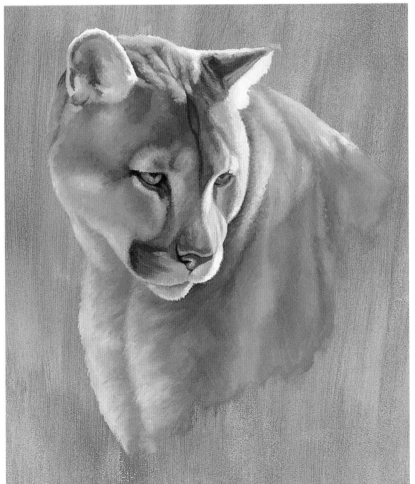

1 DRAWING ON GESSOED PANEL

The cat's head and eyes are placed in the upper left-hand quarter of the composition with the cat looking back over his shoulder. In this way, the cat's head is turned at such an angle that his gaze looks back across his body and the diagonal of the painting, creating an interesting visual dynamic.

2 TINTED PAINTING SURFACE

Use Burnt Sienna thinned down with painting medium to tint the panel. Remember to keep the wash fairly even and transparent so that you can work from the drawing beneath it.

3 FINISHED UNDERPAINTING

Again, I primarily used two grays: a warm gray made up of Cadmium Lemon and Permanent Mauve and a cool gray consisting of Viridian and Alizarin Crimson. Both grays are dulled down with Titanium White. The other main colors in the underpainting are Naples Yellow, Cadmium Yellow, Cadmium Orange and Raw Sienna. Use a no. 8 and a no. 6 flat brush to block in the major shapes and a no. 3 flat brush to block in the details.

Ears

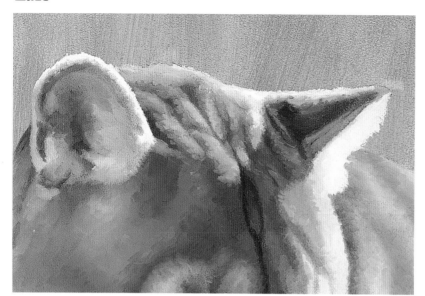

1 UNDERPAINTING

The left ear is much warmer in hue than the ear on the right, as the ear on the right is in shadow. The ear on the left has variations of the warmer gray with a touch of Cadmium Orange dulled down with Titanium White. The ear on the right has much darker and bluer grays. Both ears, however, are strongly backlit. To capture this lighting, you will need Titanium White with a touch of Cadmium Yellow. The skin between the ears appears to be wrinkled. To achieve this effect, paint lighter shades of warm tones on the high spots of the wrinkles and darker shades in the shadowed areas. I used a no. 4 flat brush to do the underpainting of the ears.

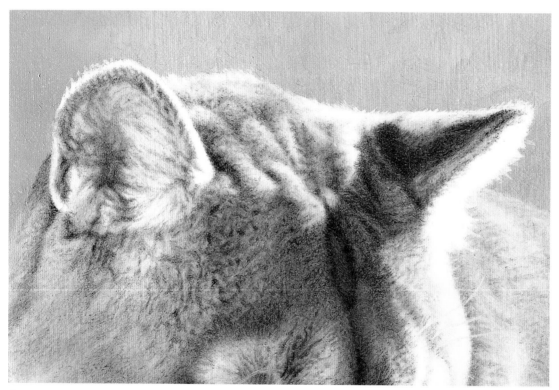

2 DETAIL OF THE FINISHED EARS

Using the dry-brush technique with Raw Umber and Burnt Umber on a no. 1 round brush, begin to paint the texture of the left ear by starting with the area in darkest shadow and moving out to the wispy, lighter colored hairs. To finish the left ear, add subtle textures to the ear's rim. For the right ear, darken the areas in shadow. Finish the area by adding texture to the surrounding fur.

Eyes

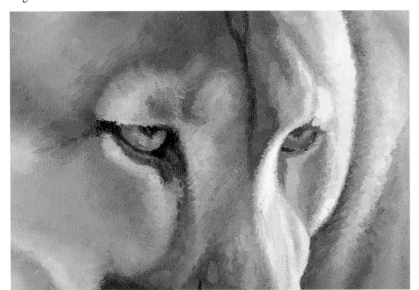

1 UNDERPAINTING

Use a combination of Permanent Green, Burnt Sienna, Cadmium Orange and Cadmium Yellow, slightly dulled with Titanium White, for the underpainting of the iris. The area around the eyes is painted with a combination of bluish grays and orange-yellow grays.

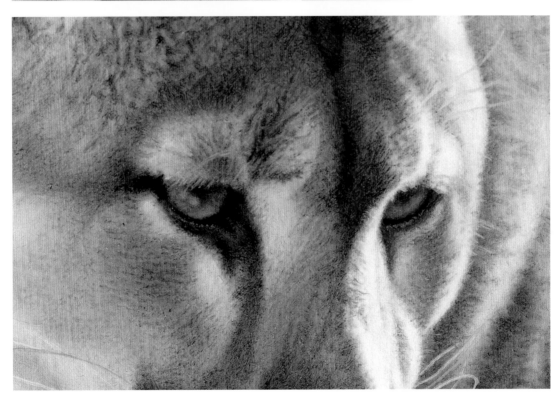

2 DETAIL OF THE FINISHED EYES

With a combination of Raw Umber and Burnt Umber, drybrush the texture of the fur in the area surrounding the eyes, with a majority of the texture in the darker areas. Mix a small amount of Ultramarine Blue into the umbers for the extremely dark areas around the eyes, including the pupil and the dark skin encircling the eyes. The final touch is to add the whiskers above the eyes using a no. 1 round brush and a very light gray.

Muzzle

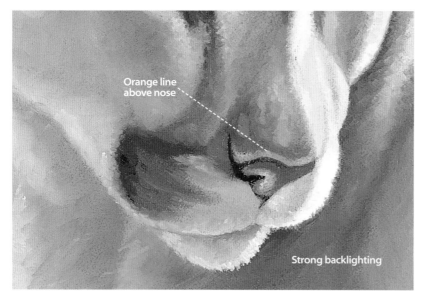

Orange line above nose

Strong backlighting

1 UNDERPAINTING

For the underpainting of the nose and the area of the whiskers, use a combination of Burnt Sienna dulled down with Burnt Umber and Titanium White. For the orange line directly above the nose, use a pure hue of Cadmium Orange slightly dulled with Titanium White. Directly above this line is a bluish gray area that gives the sense of this side of the cat being in shadow. The light taupe area around the mouth is broken up with the cooler gray line that represents the mouth. The area of the muzzle with strong backlighting is made up of Titanium White with Cadmium Yellow. A no. 3 flat brush is used to paint the details of the nose, and a no. 6 flat brush is used to block in the rest of the underpainting.

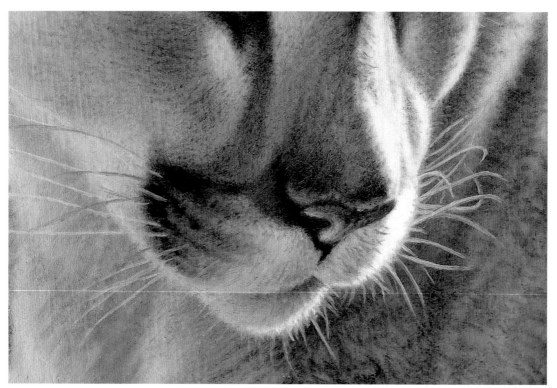

2 DETAIL OF THE FINISHED MUZZLE

Using the dry-brush technique, create the dark patterns in the whiskered part of the cheek on the left side. Continue darkening the areas in shadow around the nose and subtly allude to the texture of fur in the surrounding area of the muzzle. Because the cougar's fur isn't very long, the drybrushing used to create the texture is much less defined and lighter in color.

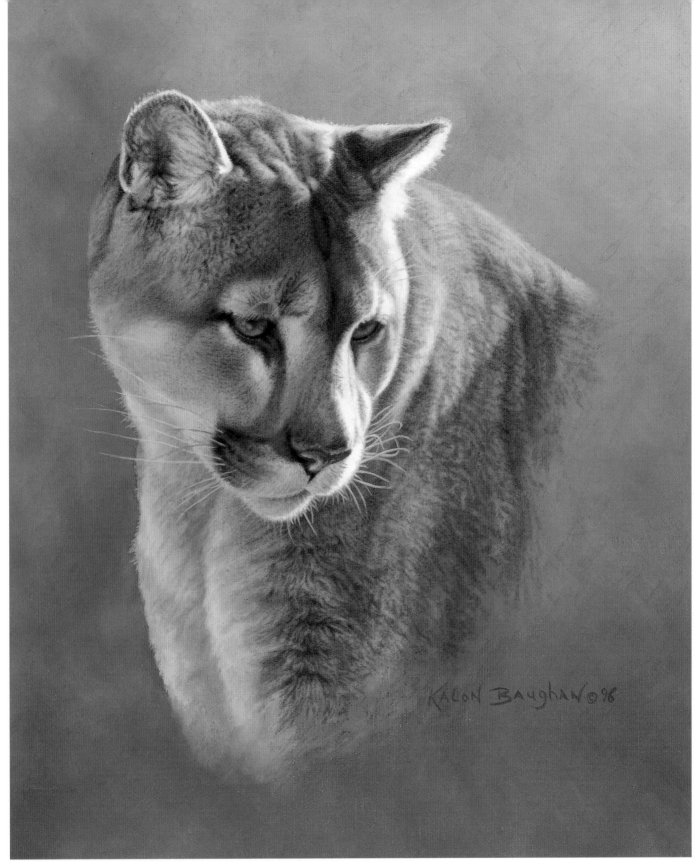

WATCHFUL EYES
Kalon Baughan, oil on canvas, 12" x 9"
(30cm x 23cm), collection of Daniel
and Sara Langren

Comments on the Finished Painting
Have you ever seen a house cat that is completely fixated on something you cannot see, seemingly ready to pounce at the slightest provocation? This was the image I was trying to capture in this cougar's intent, downcast stare. Furthermore, I was determined to enhance the mood of the painting by creating strong backlighting on one side of the cat's face and back. I also attempted to paint the fur in a much softer style. Many people who have viewed this painting have commented on how they feel like they could reach out and pet this cougar's fur. This lends credence to the suggestion that you do not have to paint each individual hair to create an alluring coat of fur.

ANTLERED MAMMALS

ne of the most commonly painted subject matters for sporting art enthusiasts are antlered big game mammals. There are several species of antlered mammals living in North America; the most common of these are elk, moose, white-tailed deer, mule deer and caribou. All of these animals share an amazing characteristic: Each year the males grow and shed an entirely new set of antlers. This is one of the main features separating them from horned mammals, which never shed their horns. People tend to have a certain fascination with antlers. I know several people, including myself, who collect them for display. Although most people collect antlers as a sign of their hunting prowess, my friends and I collect them for the sheer love of their shape and form.

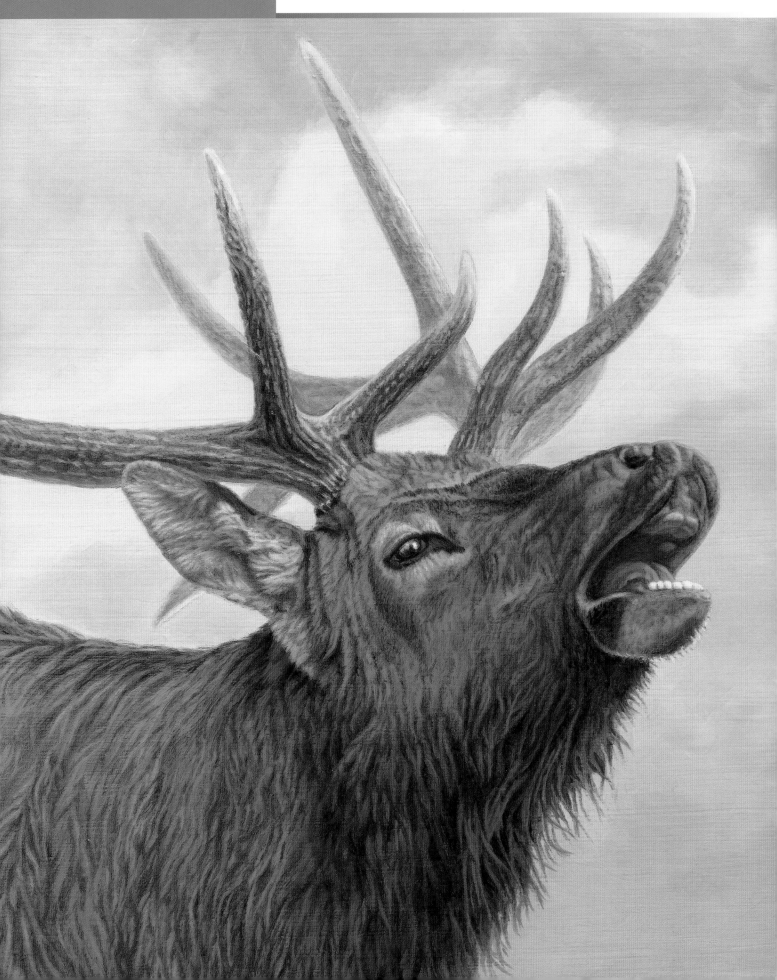

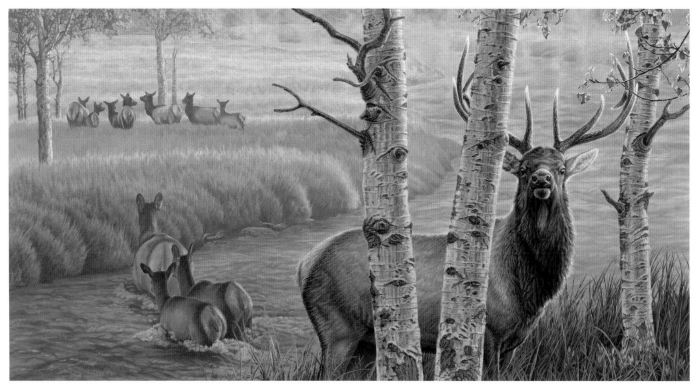

MADISON MORNING
Kalon Baughan, oil on canvas,
18" x 34" (46cm x 86cm), collection of Bob and Ann Knoop

*I*n this chapter, I chose to include painting demonstrations of my three favorite antlered mammals: elk, white-tailed deer and moose. Elk, sometimes referred to as wapiti, are very large mammals with a thick, dark neck and shaggy mane. Their bodies are generally light tan with a dark underbelly and an off-white rump patch. Adult males have extremely large antlers with long, polished tines. There are four subspecies of elk living today. The most common is the Rocky Mountain elk, which inhabits the Rocky Mountain regions of the U.S. and Canada. The Roosevelt elk and Manitoba elk can be found along the West Coast region. Tule elk, also known as dwarf elk, are found in small bands primarily in California. The best time to view elk is during the fall rutting season, when males gather harems of cow elk and display their mating rituals. This ritual is both visually and audibly captivating, as the elk display for the right to mate and the bulls bugle their haunting mating call.

I grew up on a small farm in Michigan, and one of the highlights of my childhood was viewing white-tailed deer in our fields. I was always captivated by their graceful beauty and joyfully anticipated the chance sightings of the large bucks. I also have always had a great deal of respect for white-tailed deer, as they have adapted well to human encroachment on their habitat. Unlike elk and moose, white-tailed deer can be found just about anywhere in the lower forty-eight states, with seventeen subspecies currently recognized. White-tailed deer are most active at dawn and dusk and are, therefore, most photogenic at these times. The best time to view a white-tailed buck is during the rut, as they tend to put their guard down while preoccupied with mating.

The moose is the largest living antlered mammal and is perhaps the strangest looking, as well. Moose can be 8' to 10' long (2.4m to 3m) from nose to tail and 5' to 7' tall (1.5m to 2.1m) at the shoulders. Adult males can grow huge sets of antlers, with the largest recorded size being larger than 5' (1.5m) from tip to tip. The moose is unmistakable, with its dark-colored body and light-colored legs, slim hindquarters and massive, humped shoulders. Most moose, both males and females, have a dangling appendage of skin hanging from their chin called a bell. The unusually large and overhanging nose of the moose is also a dead giveaway. There are four subspecies of moose living in North America. These are the Eastern, Northwestern, Yellowstone and Alaskan moose, with each residing in wooded areas of its namesake region.

ELK
ANATOMY

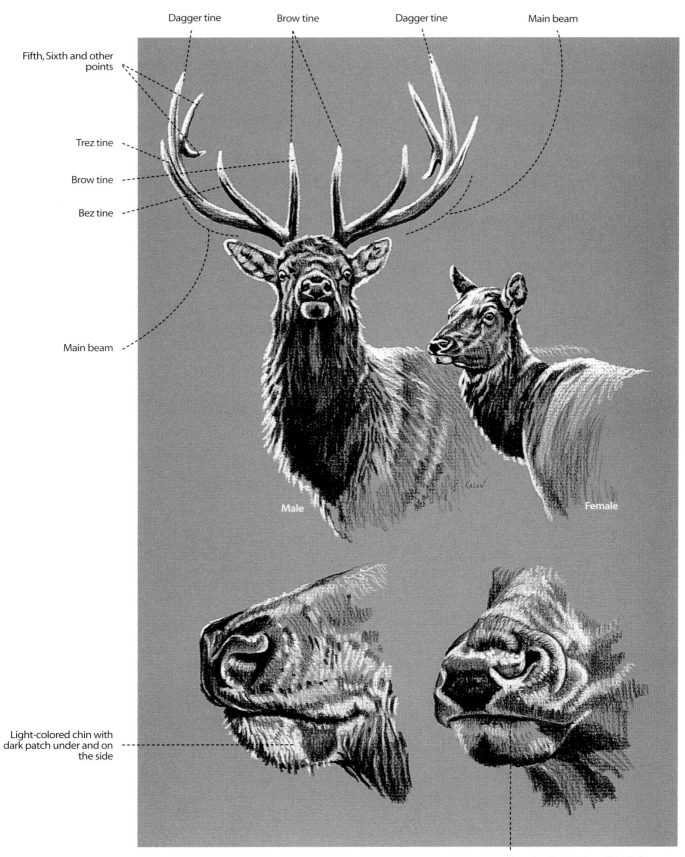

Dagger tine

Brow tine

Dagger tine

Main beam

Fifth, Sixth and other points

Trez tine

Brow tine

Bez tine

Main beam

Male

Female

Light-colored chin with dark patch under and on the side

Nose has light-colored highlights around nostrils.

WHITE-TAILED
DEER ANATOMY

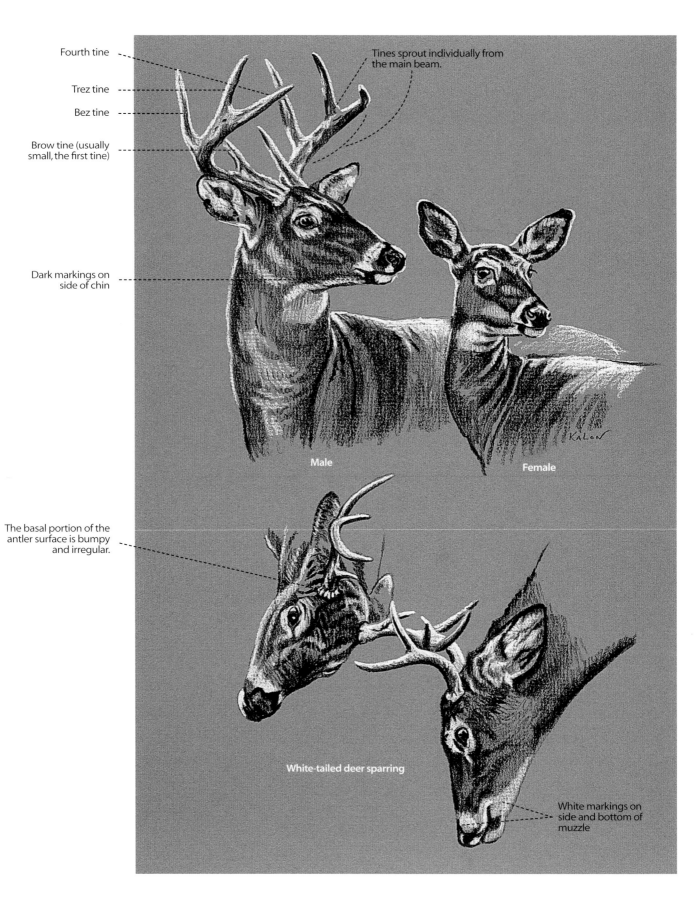

Fourth tine

Trez tine

Bez tine

Brow tine (usually small, the first tine)

Tines sprout individually from the main beam.

Dark markings on side of chin

Male

Female

The basal portion of the antler surface is bumpy and irregular.

White-tailed deer sparring

White markings on side and bottom of muzzle

MOOSE
ANATOMY

Palmate antlers are shovel-like.

Points originate from outer edge of palm.

Female

Male

Upper lip and unusually shaped nose hang over the lower lip.

Bell of the moose

7 | ELK

Getting Started

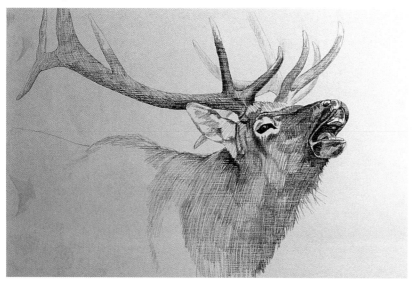

1 DRAWING ON GESSOED PANEL

I chose to depict the elk in typical rutting behavior, with his mouth open as if he is bugling. I purposely cropped some of the antler out of the picture so that I could have the elk's head, which is the focal point of the painting, in the upper right third of the composition.

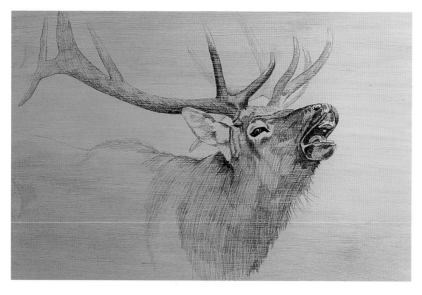

2 TINTED PAINTING SURFACE

Tint the painting surface with Burnt Sienna mixed with painting medium.

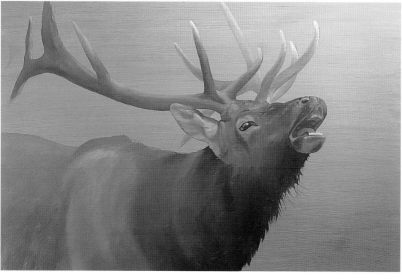

3 FINISHED UNDERPAINTING

Premix a warm and a cool gray ahead of time. The warm gray consists of Cadmium Lemon and Permanent Mauve, and the cool gray is composed of Viridian and Alizarin Crimson. Use Titanium White to dull the grays down accordingly. Use a no. 6 and a no. 4 flat brush for these areas. Next, paint the dark area of the neck, using a good deal more of the warm gray and a touch of the cool gray. Also use a touch of Burnt Umber in the darkest areas. For the large tan area of the elk's body, use both grays dulled down with Titanium White and a touch of Naples Yellow. Use a no. 10 flat brush for these areas of the painting.

Eyes

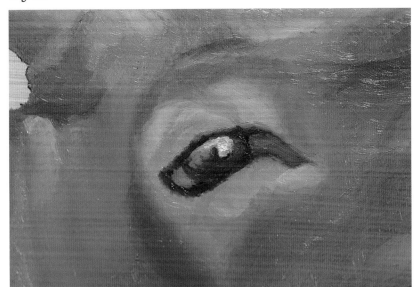

1 UNDERPAINTING

The warm and cool areas surrounding the eyes are the two grays discussed in step 3 (previous page), supplemented occasionally with Burnt Umber and Burnt Sienna and a touch of Cadmium Orange, lightened when necessary with Titanium White. When painting the details of the eye, use a no. 2 flat brush. The iris of the eye is composed of a very bluish gray supplemented with Ultramarine Blue. Mix a light salmon color for what would be the white of the eye with Cadmium Red, Titanium White and a touch of warm gray. The darkest area of the eye will be painted with Raw Umber.

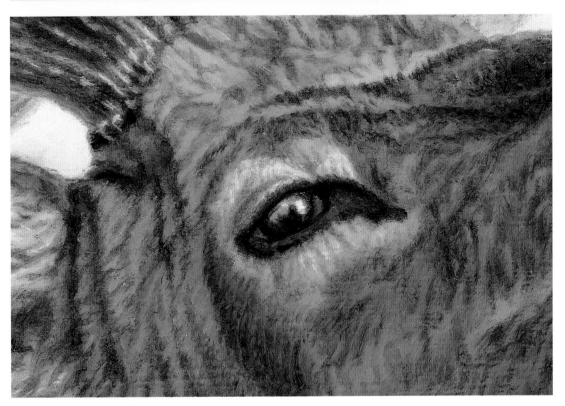

2 DETAIL OF THE FINISHED EYES

The texture surrounding the elk's eyes is very pronounced. Use Raw Umber with the dry-brush technique to achieve this look. With a no. 1 round brush and a mixture of Burnt Umber and Raw Umber and a touch of Ultramarine Blue, drybrush the darkest areas of the eye. After the drybrushing has dried, use Titanium White above and below the eye to capture the subtle reflected highlights. Also add a small dab of Titanium White in the catchlight of the eye.

Ears

1 UNDERPAINTING

The colors used in the underpainting of the ears consist mainly of warm grays supplemented with a touch of Raw Sienna and dulled down with Titanium White. There is a great deal of dimension in the ears, and if painted correctly in the underpainting, the dry-brush technique will go a lot smoother. Use a no. 6 flat brush for the underpainting of the ears.

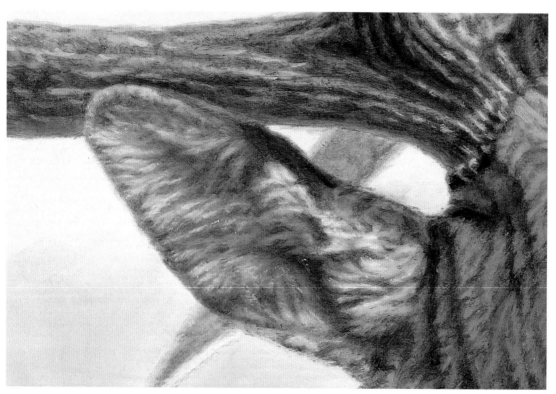

2 DETAIL OF THE FINISHED EARS

Using a no. 1 round brush, the dry-brush technique, and Raw Umber and Burnt Umber, begin to create the texture of the wispy hairs of the ear. To create the texture of the long, light-colored hairs in the ear, the dry-brush strokes will be longer and more fluid. Note that the undulating aspects of the ear are created by adding dark shadows toward the middle of the ear and around the ear's edge.

Muzzle

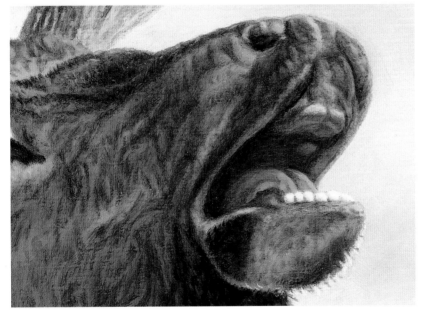

2 DETAIL OF THE FINISHED MUZZLE

In an area where there is so much detail and three-dimensional form as in this open muzzle, you must have a well-developed underpainting before you begin the dry-brush technique. Remember, drybrushing is more or less a patina that creates texture. Now begin drybrushing the textures of the fur in the surrounding areas of the muzzle. After that is finished, start darkening the areas of the lower jaw, tongue, teeth, upper roof of the mouth, curled-back upper nose, and nostril. Essentially, you are redefining the underpainting with Raw Umber and Burnt Umber, and in the darkest areas add Ultramarine Blue to the mixture. After the paint has dried, use a no. 1 round brush and warm, light colors and go back into areas of the muzzle, like the nose, the teeth, the tongue, the edge of the lip and the palate of the mouth, to create the illusion of highlights.

1 UNDERPAINTING

Painting the muzzle is difficult enough, but painting an open, bugling muzzle can be quite a challenge. Mainly, it's the anatomy that is the most challenging here. To begin painting the muzzle, you can see that there are more bluish grays used on the nose and the lip region. For these areas, use the cool gray mixed with Ultramarine Blue and dulled down with Titanium White where appropriate. The tongue, the trailing edge of the upper lip and the inside of the nostril are painted with a reddish pink tone. This can be created by mixing Cadmium Red, a touch of Cadmium Orange, a warm gray, and touches of Titanium White when dulling is needed. Next, block in the shape of the surrounding lower jaw and muzzle area with warm grays, Raw Sienna, Burnt Sienna, and a touch of Cadmium Yellow and Cadmium Orange. In the very darkest areas, use a mixture of Raw Umber and Ultramarine Blue. Finally, block in the lower teeth with a mixture of Titanium White and Naples Yellow. For the details, such as the nose, teeth and tongue, use a no. 2 flat brush, and for the larger areas of the muzzle, block it in with a no. 6 to a no. 8 flat brush.

Antlers

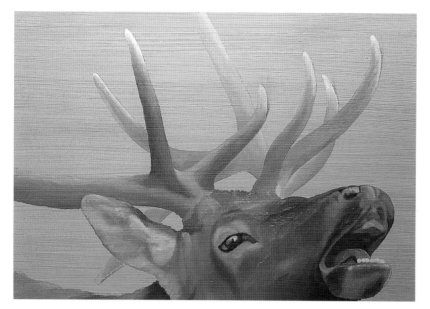

1 UNDERPAINTING

Paint the underpainting of the antlers with a mixture of the two grays, adding a touch of Cadmium Orange, Naples Yellow and plenty of Titanium White to the lighter areas of the tines. Usually, the tips of the tines of the elk have been polished by the elk; therefore, they are much lighter in color. Keep in mind your light source, as painting the tines and main beam of the antlers is similar to painting a smooth tube with light and shadow in the respective areas. To create the effect of atmospheric perspective, add more Titanium White to the underpainting of the antler farthest from the viewer.

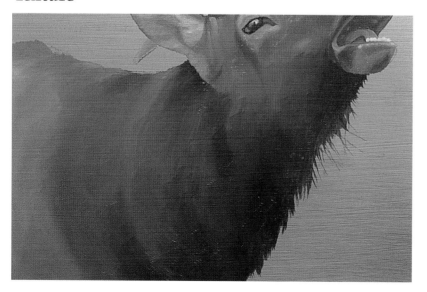

2 DETAIL OF THE FINISHED ANTLERS

Surprisingly, elk antlers have a great deal of texture, especially down near the burr and the basal areas of the tines and the main beam. The texture in these areas resembles a deeply furrowed and beaded surface, decreasing in texture closer to the tips of the tines. To achieve this texture, use the dry-brush technique with a no. 1 round brush and Burnt Umber and Raw Umber. The final step, after the dry-brush paint has dried, is to further enhance the illusion of atmospheric perspective on the antler farthest from the viewer by adding a thin wash of Titanium White and a touch of Ultramarine Blue.

Texture

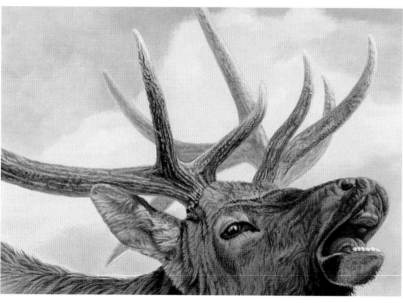

1 UNDERPAINTING

Using a no. 10 flat brush, use a mixture of the warm gray mentioned earlier, supplemented with Burnt Sienna and Raw Sienna and dulled down with Titanium White where needed. Block in the underpainting of the elk's thick neck. The light source is coming from the top, so it will be darker along the elk's jowls and neck.

2 DRYBRUSHING

The dry-brush technique is essential and effective in creating any sort of texture, especially that of long, shaggy fur. I left a portion of the underpainting showing to allow you to see the drastic difference that drybrushing can make. Create this texture by using a no. 1 round brush and a mixture of Raw Umber and Burnt Umber. Do not create clumps of hair; instead, allow the hair to visually weave amongst itself, creating irregular patterns in the fur. Darken the fur in the shadowed areas of the elk and lighten the fur on top of the animal's neck and back.

3 FINISHED FUR

Another important factor in creating fur textures is painting realistic edges. Try to make your edges appear realistic by having irregular patterns along the edge and softening the fur, as if a small amount of light shines through the hairs at the edges. I often see wonderful paintings that are hampered by poor edge quality. Last but not least, highlight individual hairs or clumps of hairs with lighter-colored paint to create more depth.

ELK PORTRAIT
Kalon Baughan, oil on panel, 18" x 24" (46cm x 61cm), collection of Harvey and Jan Payne

Comments on the Finished Painting
Fall is my favorite time of the year. In fact, I am seldom in my studio painting at this time of the year, as I am frequently out in the field observing and photographing elk at their breeding grounds in Rocky Mountain and Yellowstone National Parks. In this painting, I tried to capture the majestic bull elk as he bugles. I chose not to include a horizon line in this painting, instead painting a background of turbulent clouds. This creates the effect of the elk standing on high ground, with the viewer looking up at him.

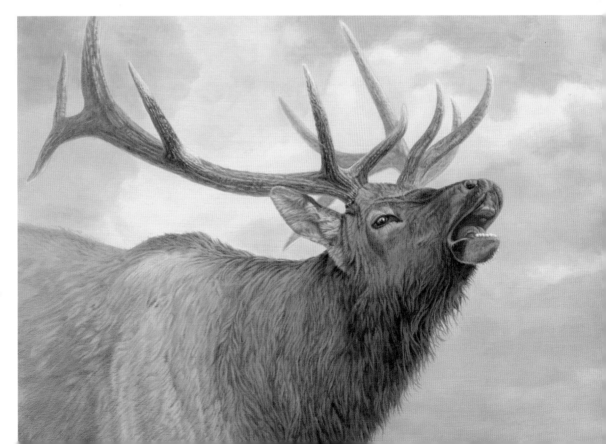

8 | WHITE-TAILED DEER

1 DRAWING

Lightly draw in the deer with an HB graphite pencil. Capture the anatomy and light source as effectively as you can.

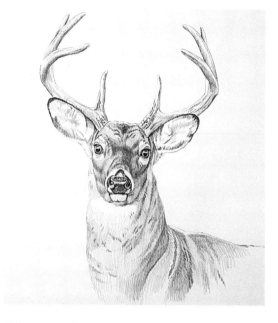

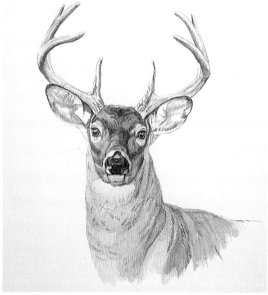

WHITE-TAILED DEER PORTRAIT
Kalon Baughan, watercolor on Strathmore paper,
14" x 11" (35cm x 28cm)

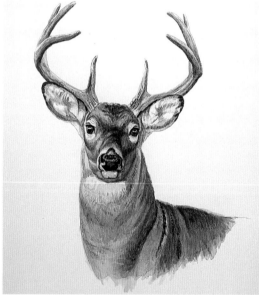

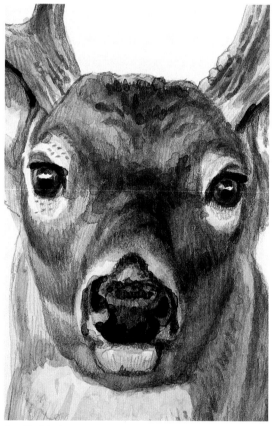

2 UNDERPAINTING

Watercolor demands that you build up layer by layer until you have achieved the color density that you desire. Start by mixing light washes of Raw Sienna and Burnt Sienna with a touch of Naples Yellow for the tan parts of the deer's coat. Use Ultramarine Blue and Alizarin Crimson for the lighter areas that are in shadow, such as the ears, under the chin and around the nose. Mix a thin wash of Cadmium Orange and Cadmium Red for the inside of the ear. Use a no. 6 round brush for the underpainting of the deer.

3 FINISHED WATERCOLOR

Refine the painting by adding layer upon layer of washes. Add Raw Sienna and Yellow Ochre to the neck and various parts of the forehead while getting redder and adding more Burnt Sienna toward his back and the right side of his face. Develop the antlers, much like you would the rest of the body, keeping the light source in mind, as it is important to create a three-dimensional effect here.

Detail of the Face
Paint the irises with a mixture of Cadmium Orange and Burnt Sienna, leaving the white patch around the eyes and the highlight in the eyes unpainted. For the nose, use a combination of Alizarin Crimson and Ultramarine Blue. Paint the darkest areas of the nose and eyes (pupil, eyelashes, nostril and the underside of the nose) with pure black.

9 | MOOSE

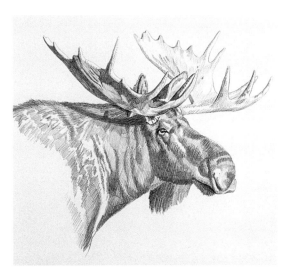

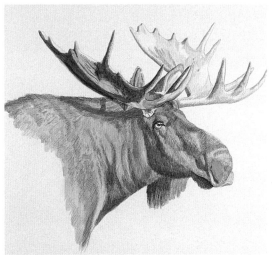

MOOSE PORTRAIT
Kalon Baughan, watercolor on
Strathmore paper, 11" x 14"
(28cm x 35cm)

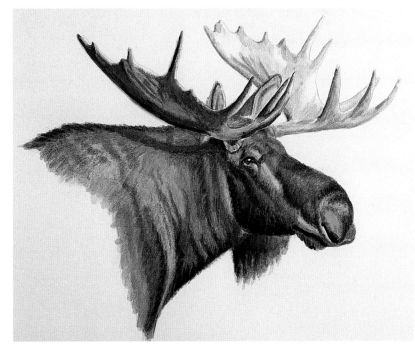

1 DRAWING

This is a profile of a young Alaskan bull moose. I
chose the profile because the moose's true character
is allowed to come forth from this perspective.

2 UNDERPAINTING

Begin painting the areas in highlight first, with
Cadmium Orange and Naples Yellow, such as the tip
of the nose, the forehead and the shoulder. Choose
darker browns mixed with Alizarin Crimson for
defining the areas of the jowl, the bell, the chin and
the top of the nose. For the part of the antler that is in
extreme shadow, use a deep blue color.

3 FINISHED WATERCOLOR

For the lighter areas, continue adding layers of
Cadmium Orange and Naples Yellow, while also
adding Cadmium Yellow accordingly. Continue dark-
ening the other areas of the muzzle and face with
darker browns. To create atmospheric perspective on
the palmate antler farthest from the viewer, develop
this antler only with light washes, while developing
the antler closer to the viewer with richer colors.

Detail of the Face
The eye is developed with a light
rim on the bottom painted with
Cadmium Yellow, while the rest of
the eye is in shadow. The pupil is a
darker brown than the iris, while
leaving the white of the paper to
show through for the highlight in
the eye. Paint with strokes that
follow the undulating contours of
the animal's musculature and
bone structure in order to define
more clearly the three-dimen-
sionality of the animal.

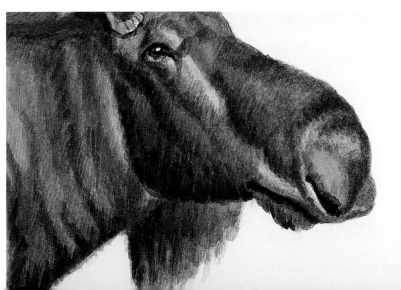

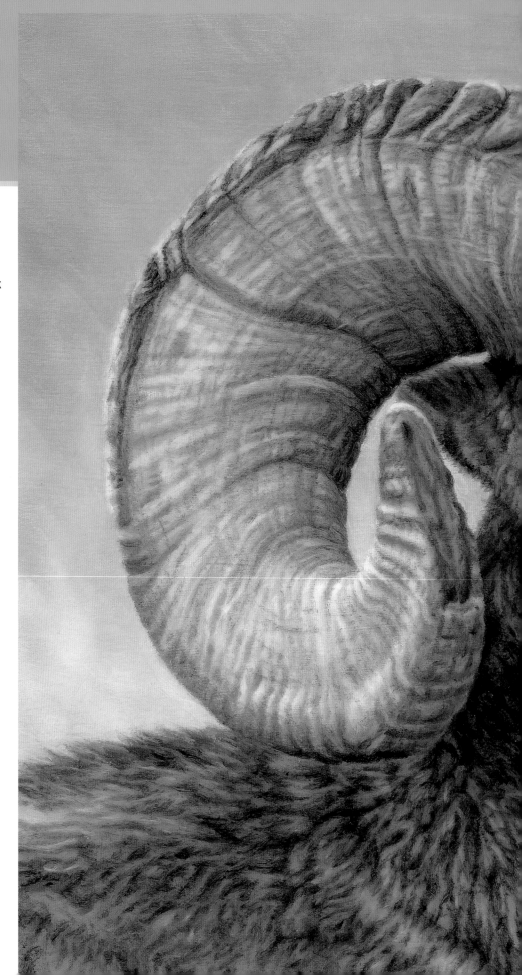

HORNED MAMMALS

here are several horned mammals in North America, including the bighorn and Dall sheep, the American bison, the mountain goat, the musk ox and the pronghorn. The main demonstration in this chapter will be of a bighorn ram. The bighorn sheep is a truly amazing animal. It inhabits the high mountains of the western region of North America, surviving in climates and environments that most animals could not. Bighorns vary from dark brown to light tan. Gifted with massive horn structure, the bighorn tends to "broom" or file the tips of its horns on rocks to help its peripheral vision.

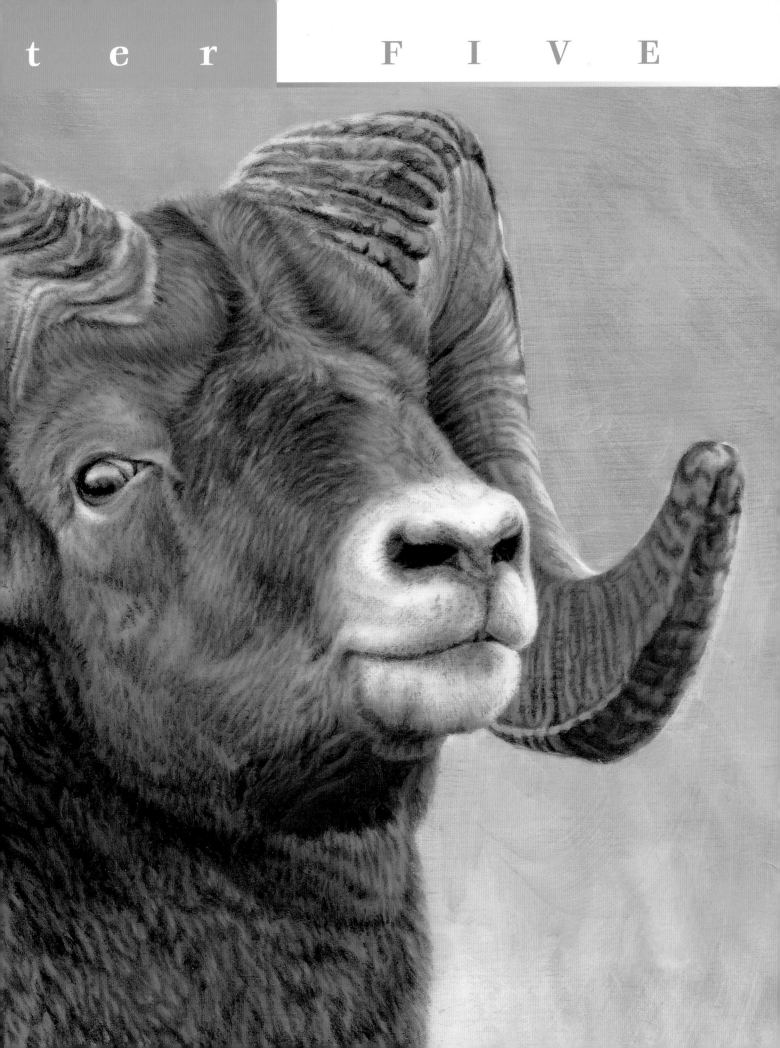

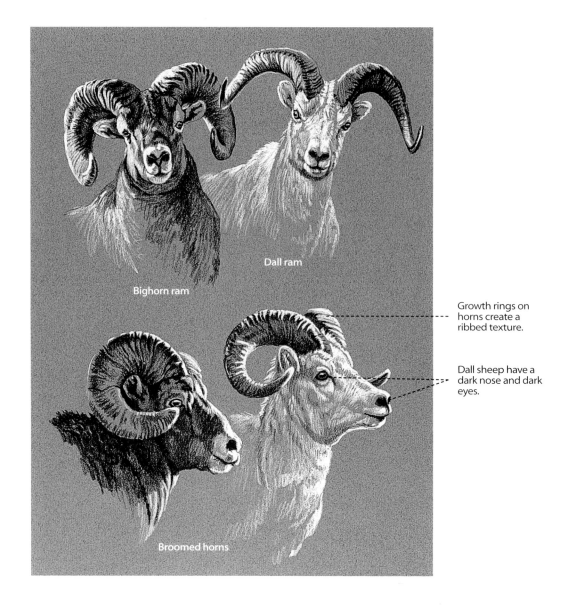

Bighorn ram

Dall ram

Broomed horns

Growth rings on horns create a ribbed texture.

Dall sheep have a dark nose and dark eyes.

nother amazing animal, the Dall sheep tends to live farther north than the bighorn. The most telling differences between the bighorn and the Dall sheep are their coloring and the shape of their horns. The Dall sheep is almost entirely white, and its horns tend to be much more slender and less massive than those of the bighorn.

The American bison, also known as buffalo, has a dark, massive head with a shaggy coat and a thick mane and beard. It is also highly distinguishable with its large shoulder hump. Both male and female bison have short, dark-colored horns that flare out from the sides of their heads. Bison once roamed huge areas of North America. Today, they can be found in various sizes of herds mainly in the prairie regions of the West, such as in Yellowstone National Park.

The pronghorn, also called antelope, has unusual markings on its neck and head that make

it difficult to confuse with any other mammal. Both the males and females have dark-colored, forked horns and a dark nose. The pronghorn has a light tan head with white markings on the sides of its cheeks and chin and two distinct bands of white running across the front of its neck. Pronghorns can be found in open grasslands across the central west, from southern Alberta, Canada, to Arizona and Mexico.

The mountain goat is another horned mammal that is very popular to paint. It has an off-white coat with a distinct beard hanging from its chin. The nose, eyes and horns are black. The dark, smooth horns are slightly curved backwards and are relatively short, with the female's being smaller. Mountain goats can be found in pockets across the West, where there are steep mountains above the timberline. My favorite place to view them is in Glacier National Park in Montana.

Note the
characteristic hump.

The male is much larger
than the female.

Both males and
females have beards.

Male

Female

Bison

Note the distinct white
markings on the neck.

Pronghorn

Mountain goat

Both male and female
mountain goats have
beards.

10 | BIGHORN RAM

Getting Started

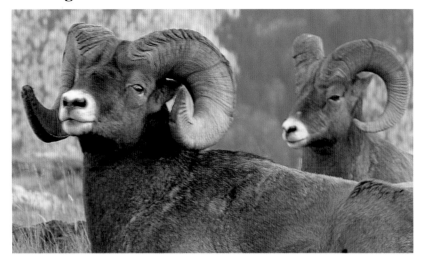

1 REFERENCE PHOTO
This is the reference photograph that I used for my painting of the bighorn ram. This photograph was taken in the evening at Banff National Park in Canada. This ram was in a small band of other rams. Although he looks as though he is posing for my camera, he is actually displaying his dominance over the rest of the rams with his head held high. *(photo by Kalon Baughan)*

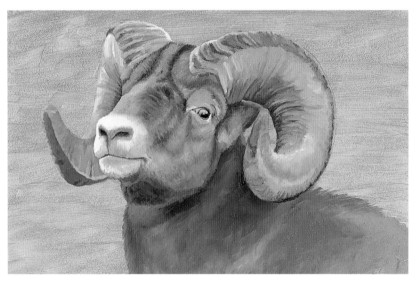

2 UNDERPAINTING
As in all of the other demonstrations, this underpainting has a tinted, complete drawing beneath it. I mixed up two grays that were supplemented with other colors for the majority of this underpainting. The warm gray is composed of Cadmium Lemon and Permanent Mauve, while the cool gray is comprised of Viridian and Alizarin Crimson, with both grays dulled down with Titanium White. The other colors used to supplement the grays include Cadmium Yellow and Cadmium Orange, Naples Yellow, Burnt Umber, Raw Umber and Ultramarine Blue. Use a no. 10 to a no. 6 flat brush for the underpainting.

Eyes

1 UNDERPAINTING
The light-colored areas of the eyes can be created with a mixture of Titanium White, Cadmium Red and Cadmium Orange. The iris of the eye is mainly comprised of Burnt Sienna, a touch of Cadmium Orange, and Titanium White. The pupils and the dark areas around the eye are composed of a mixture of Raw Umber with a touch of Ultramarine Blue. Paint all of the detailed areas of the eyes with a no. 1 round brush. The fur surrounding the eyes is painted with the warmer gray, supplemented with Naples Yellow and Cadmium Orange. This can be painted using a no. 6 flat brush.

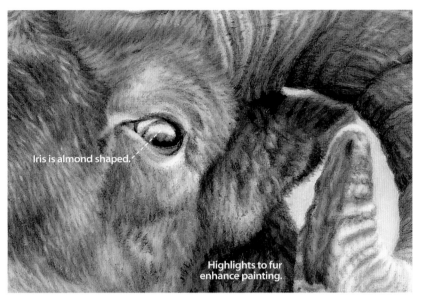

Iris is almond shaped.

Highlights to fur enhance painting.

2 DETAIL OF THE FINISHED EYES

Add the final touches to the eyes by defining their darkest areas and the texture of the fur around them using the dry-brush technique. The colors used in the dry-brush technique are primarily Raw Umber, mixed with Ultramarine Blue only in the darkest areas, such as the pupil and the rim of the eye. In this painting, there is a great deal of highlighting to be done when the drybrushing has dried. Primarily use Titanium White for these highlights, adding a touch of Cadmium Red for the highlight in the sclera of the eyes.

Muzzle

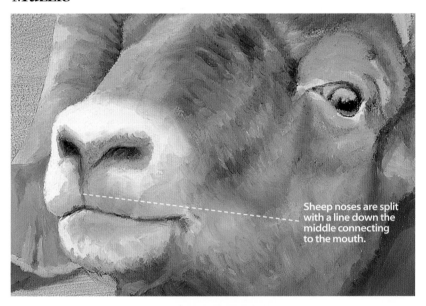

Sheep noses are split with a line down the middle connecting to the mouth.

1 UNDERPAINTING

As shown in this painting, the sheep's muzzle is broken up into two distinct areas. The chin and nose areas are off-white, which can be created using Titanium White and a touch of warm and cool grays. The jowl and bridge of the nose, on the other hand, are painted with much darker values of brownish grays. Use Raw Umber to lightly block in the shape of the mouth. These values are interspersed with cool blue-grays, such as along the top of the nose, indicating the reflection of the sky in the fur. Use a no. 6 flat brush for the underpainting, but use a no. 1 round brush to paint the defining line in the mouth.

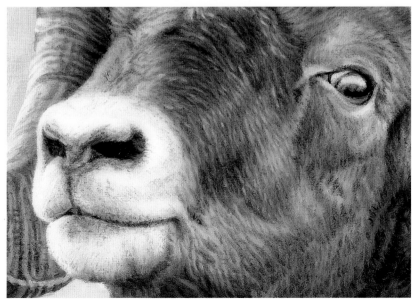

2 DETAIL OF THE FINISHED MUZZLE

Use a no. 1 round brush, the dry-brush technique and Raw Umber to paint the texture of the fur in the dark brown areas of the muzzle and to lightly mottle the white area of the muzzle. Mix Ultramarine Blue into the darkest areas of the muzzle, such as the nostrils and the line of the mouth. Note how the direction of the hair parts from the bridge of the nose and follows the contour of the muzzle downward. After the dry-brushing has dried, begin highlighting with lighter tones, making sure to follow the same direction in the fur that you used when drybrushing. Use more opaque white when highlighting the nose and chin.

Horns

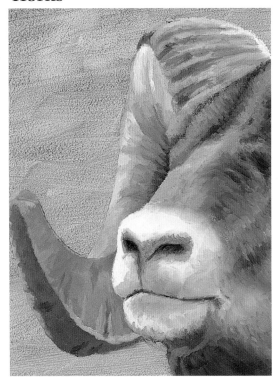

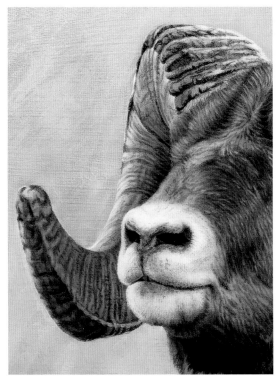

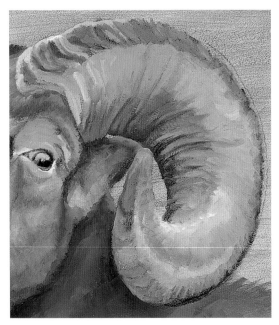

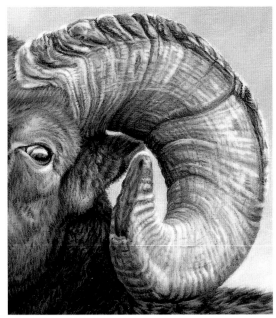

1 UNDERPAINTING

The horns of this ram are broken down into several different planes. The horn on the left has the most area in shadow, with the underpart of the horn painted with a dark, cool gray. The inside of the horn, near the tip, is painted with a medium-toned, bluish gray. The natural color of the sheep's horns is a light tan, with a majority of the horns painted with warm grays supplemented with Raw Sienna, Naples Yellow, and a touch of Cadmium Yellow and Cadmium Orange. This mixture is dulled down with Titanium White in the appropriate areas.

2 DETAIL OF THE FINISHED HORNS

Use the dry-brush technique with a no. 1 round brush and Raw Umber to define the textures of the horns. The sides of the horns are comprised of two different types of textures. The most notable is the growth rings that encircle the horns, but there are also more subtle lines that run the length of the horns, creating a cross-hatching pattern. Note that the tip of the horn on the right has been broomed back. Highlight the horn with lighter colors, mainly using Titanium White with Cadmium Yellow and Cadmium Orange.

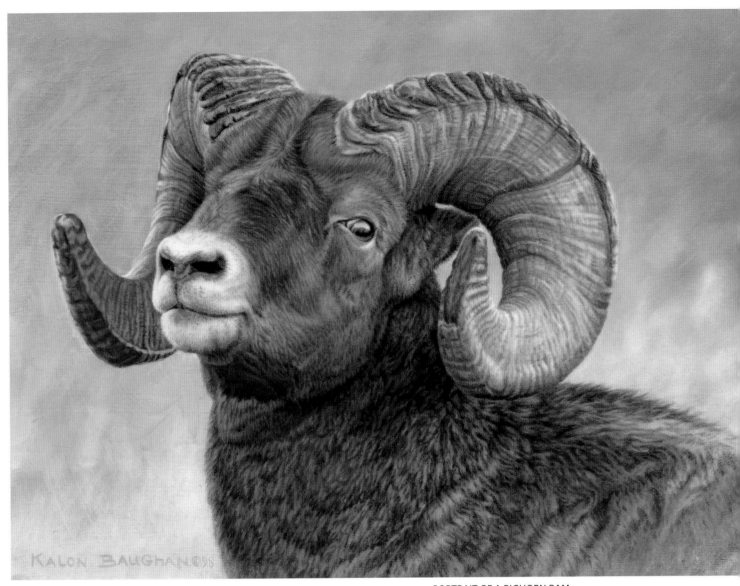

PORTRAIT OF A BIGHORN RAM
Kalon Baughan, oil on panel, 9" x 12" (23cm x 30cm), collection of Steve and Mary Ann Iverson

Comments on the Finished Painting
The uptilted head and side-glancing eye of this bighorn indicate his sense of dominance and willingness to engage in the head-butting ritual that occurs in late fall to determine the breeding ram. If you ever have the chance to witness rams clashing in nature, you will understand my interest in trying to capture the intensity in the ram's forceful stare just prior to this event. In this painting I purposefully painted the ram in such a way as to highlight the aesthetically pleasing curve of the horn.

11 | AMERICAN BISON *(ALLA PRIMA)*

Getting Started

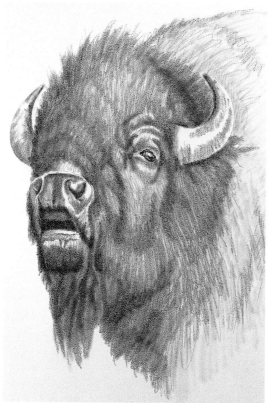

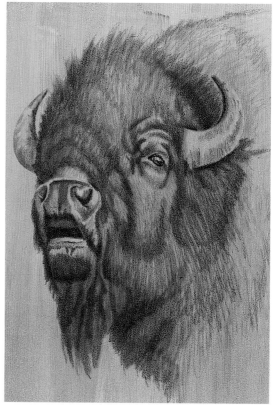

1 DRAWING ON GESSOED PANEL

This is a head study of a bull bison. I tried to capture this bison in the midst of bellowing, which is a common mating ritual during the spring and fall rut.

2 TINTED PAINTING SURFACE

Using a combination of Burnt Sienna and painting medium, tint the painting surface, allowing the drawing to show through.

3 UNDERPAINTING

This demonstration will be painted in the style of *alla prima* or direct painting. Using this quick, loose style allows you to finish the painting in an afternoon. The finished product will, therefore, be much more Impressionistic than the detailed paintings of the previous demonstrations. Begin the underpainting by premixing certain colors that will be used the most, such as the rich, medium-toned blue used as the highlights in the bison's dark, shaggy fur. This color is created by mixing Viridian and Alizarin Crimson dulled down with Titanium White and accented with a touch of Ultramarine Blue. Use a no. 6 and no. 10 flat brush to block in these areas.

Muzzle

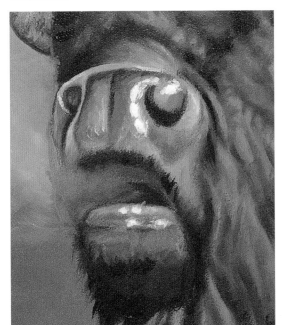

Eye, Horn and Hump Details

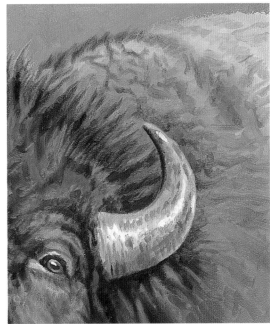

The iris of the eye is comprised of Burnt Sienna and a touch of Cadmium Red, with the pupil and the underside of the eyelid painted with Raw Umber and Ultramarine Blue. When painting the details of the eye, use a no. 1 round brush. Paint the horn with lighter tones, intermixing both warm and cool colors. The horns are catching a great deal of light; therefore, they are much lighter than the fur of the bison. The hump of the buffalo is painted with a combination of Burnt Sienna, Raw Sienna and Titanium White, using Raw Umber to create the wooly, matted texture of the fur.

After painting the highlights of the head, begin using lighter and darker colors to develop the textures and contours of the nose and mouth. Use light, warm tones around the areas of the lower and upper lip and the upper part of the nose, and much darker tones in the shadowed areas of the chin, the interior of the mouth, the nostrils and the darkest areas of the fur. Lastly, add pure Titanium White to the highlights of the nose and lower lip. When painting the muzzle, use a no. 2 flat brush for the detailed areas.

BISON PORTRAIT
Kalon Baughan, oil on panel,
12" x 10" (30cm x 25cm)

Comments on the Finished Painting

Painting alla prima can be an enjoyable way to paint, as within a couple of hours you will have a finished painting. This is an excellent technique to use if you want to make color studies for painting or for a more Impressionistic finished painting. This is also a great technique for painting wildlife in the field.

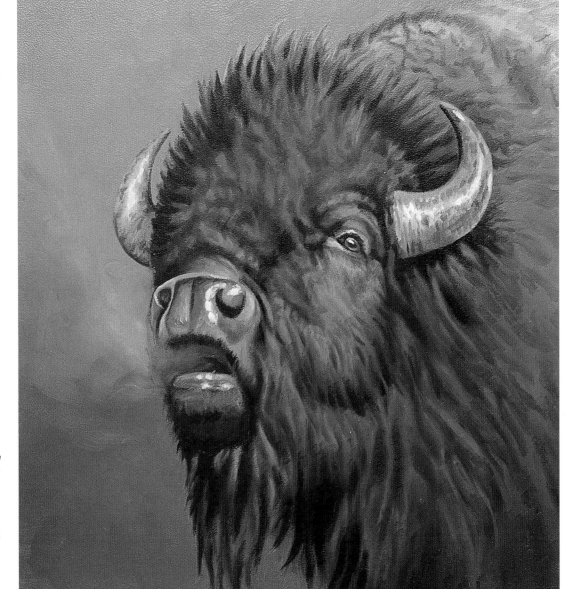

SMALL MAMMALS

he coyote and fox share many similar facial features. The coyote is much larger than the red fox, but each has a long, slender snout with a dark nose and large, pointed ears. The coyote has an orangish-gray coat, while the fox is more orange in color with a white underbelly and distinct black markings on the back sides of its ears. Both the coyote and red fox are expanding their range and are common across North America. The arctic fox, however, is quite distinct looking when compared with the coyote and red fox. Its winter coat is all white, with the only color coming from its dark nose and eyes. The shape of the arctic fox's face has a lot to do with the environment it lives in—the Arctic. Therefore, it has short, rounded ears, a blunt snout and thick fur to help prevent heat loss from the cold.

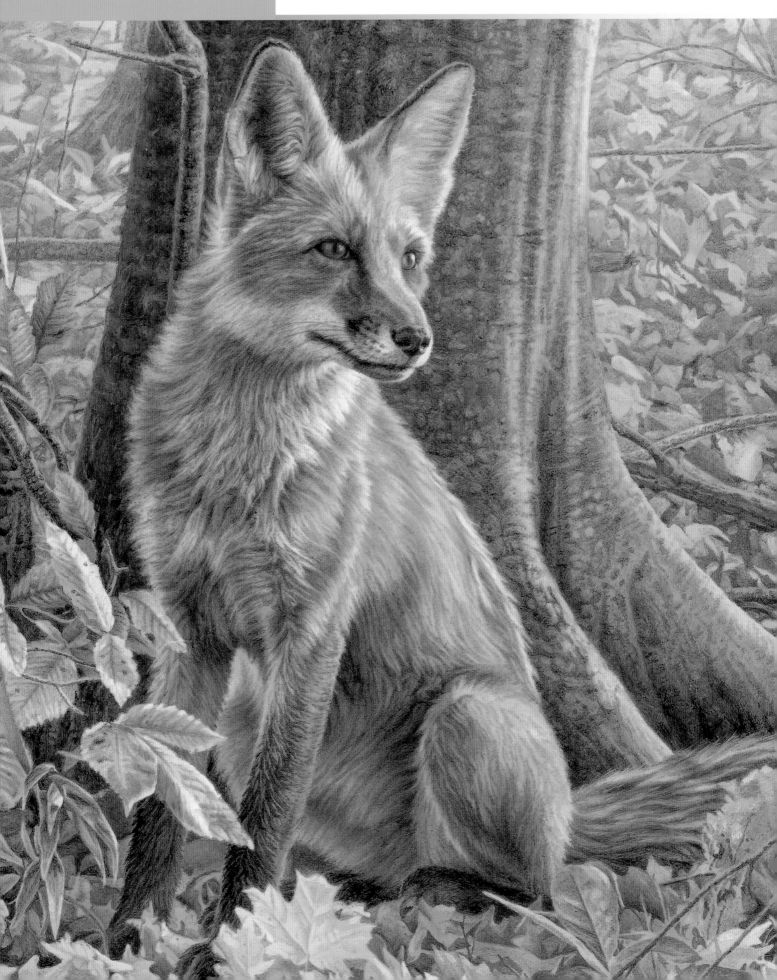

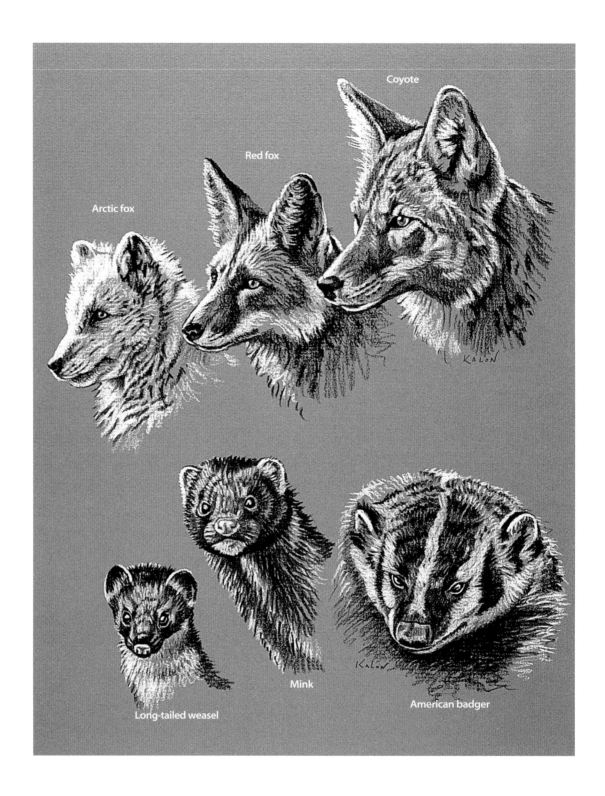

Arctic fox

Red fox

Coyote

KaLoN

Long-tailed weasel

Mink

American badger

KaLoN

The badger, mink and weasel all share similar facial features, such as rounded ears, silky textured fur and a buttonlike nose. The badger, however, has distinct black and white stripes running laterally alongside and down the center of its face. All of these animals have the characteristic beady, front-facing eyes of a predator. The mink and weasel inhabit most areas of the U.S. and Canada, except for the southwestern parts of the U.S. The badger is found mostly in the western and central parts of the U.S. and most of southern Alberta, Canada.

A very popular backyard mammal to paint is the Eastern fox squirrel. They range from the East Coast to as far west as the front range of the Rocky Mountains. Several similar species also inhabit the western regions of the U.S. Because of their tolerance of urban environments, they are often seen in cities, parks and, most often, near bird feeders. The fox squirrel has several

FOX AND CENTURY PLANT
Kalon Baughan, charcoal on paper,
7" x 12" (18cm x 30cm), collection
of the artist

Photograph of an Eastern fox squirrel taken in my backyard. (photo by Kalon Baughan)

color phases, varying from rust colored to gray to black, with some variations having white ears or white dash marks on the front of the face. The facial characteristics of the squirrel are short, rounded ears and a gently sloping forehead that ends at the tip of the nose. The lower jaw is sometimes hidden by the upper cheek and jowl. The predominant feature of the squirrel is its large almond-shaped eyes located on the sides of its head so as to see possible predators.

12 | RED FOX

Getting Started

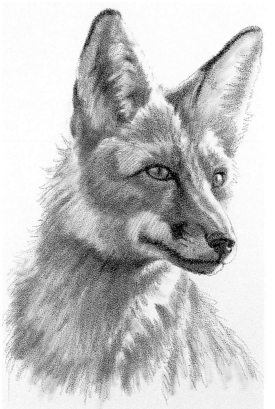

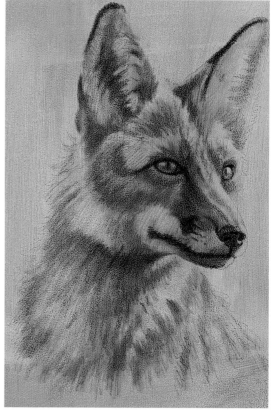

1 DRAWING ON GESSOED PANEL

This demonstration focuses only on the head of the fox in the painting at the beginning of the chapter. At the end of the demonstration, I will talk about how to integrate the portrait into the rest of the painting. For this drawing, I used an HB drawing pencil and later softened the lines with a cotton swab.

2 TINTED PAINTING SURFACE

As usual, use a wash of Burnt Sienna and painting medium to tint the gessoed panel, allowing the drawing to remain visible through the wash.

3 FINISHED UNDERPAINTING

For this underpainting, premix a brown-orange gray using Cadmium Orange and Ultramarine Violet and a cooler blue-violet gray with Cadmium Red Deep and Manganese Blue. Both of these colors can be dulled down with Titanium White. Other colors used in the underpainting are Naples Yellow, Raw Sienna, Cadmium Orange and Cadmium Yellow. For the detailed areas of the underpainting, such as the eyes, muzzle and ears, use a no. 2 and no. 4 flat brush. And for the larger, more general areas, use a no. 8 and no. 6 flat brush.

Eyes

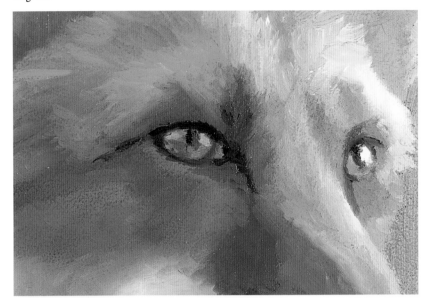

1 UNDERPAINTING

The iris of the eyes is comprised of several different colors, with Burnt Sienna, Cadmium Orange and Naples Yellow for the warm areas and light, cool gray for the upper part of the iris. Note that the fox's head is heavily back- and sidelit, making the eye on the right gather more light. This makes the right eye lighter in value and with a larger catchlight. For the pupil and the dark rim around the eye, use a mixture of Raw Umber and Ultramarine Blue. The values of the colors in the fur around the eyes are also affected by the strong backlighting.

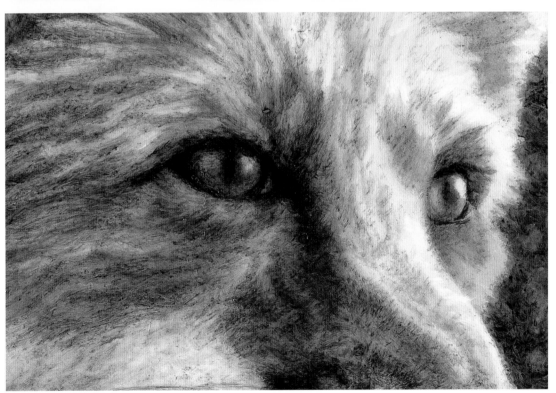

2 DETAIL OF THE FINISHED EYES

Using Raw Umber and a no. 1 round brush, drybrush the texture of the fur around the almond-shaped eyes. Note how the texture of the fur seems to start at the tear duct and radiate out and around the eye. For the darker areas of the eye, such as the pupil and rim of the eye, add a touch of Ultramarine Blue to the Raw Umber. When the drybrushing has dried, go back into the painting and further develop the highlights in the texture of the fur and the catchlights of the eye. To do this, use a mixture of Titanium White and a touch of Raw Sienna.

Muzzle

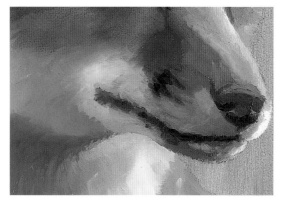

1 UNDERPAINTING

The fox's muzzle is made up of two distinct bands of color. The bridge and side of the nose are orangish values, with the top of the nose being much lighter in value as a result of the direction of the light. The lower part of the muzzle is comprised of a white band of fur that runs down the center of the fox's chest and underbelly. To paint this area, use a variety of cool, blue-gray colors, with the area under the jowl and the tip of the snout being the darkest grays. Mix a dark hue with Raw Umber and Ultramarine Blue for the darkest areas of the muzzle, such as the nose, the line of the mouth and the patterned area where the whiskers originate.

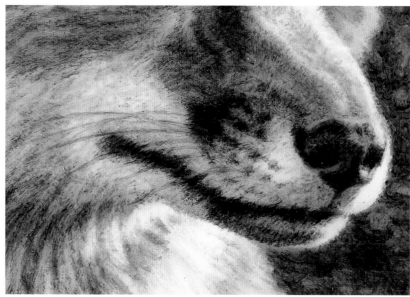

2 DETAIL OF THE FINISHED MUZZLE

Drybrush the textures in the fur around the muzzle. Develop further the dot pattern on the side of the muzzle where the whiskers originate. Use your darkest values in the nostrils and the line of the mouth. After the drybrushing is dry, highlight the right side of the muzzle and the bridge of the nose with lighter values.

Ears

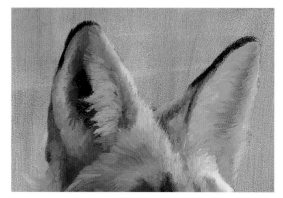

1 UNDERPAINTING

Use a variety of warm colors to develop the ears. Use lighter shades for the soft, wispy hairs inside the ears and where the light catches the right sides of the ears. Use much darker valued warm colors to develop the interior portion of the ear and the edge of the ear. Use a mixture of Raw Umber and Ultramarine Blue for the dark rim on the upper part of the ear and the shadowed interior.

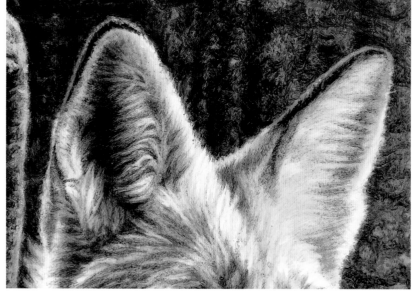

2 DETAIL OF THE FINISHED EARS

Using the dry-brush technique, develop the texture of the fur inside and around the ears, paying special attention to the direction of the fur. Again, be careful not to make the fur pattern too regular, as this will not look natural. Instead, break up the fur pattern into irregular clumps.

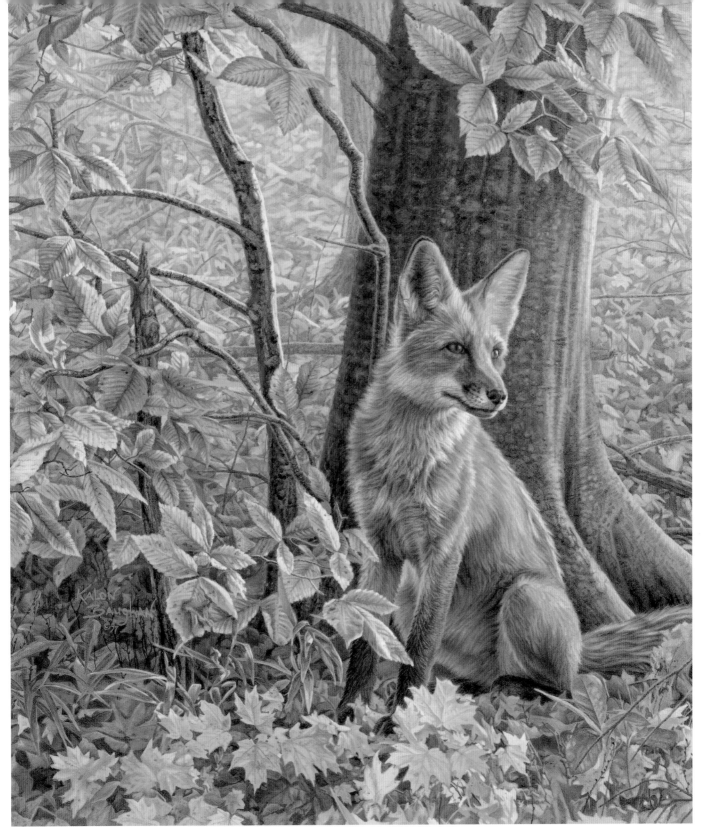

EYES OF AUTUMN
Kalon Baughan, oil on canvas, 22" x 19" (56cm x 48cm), collection of Dr. Daniel and Kathy Huycke

Comments on the Finished Painting

The fox has historically been known for its wily character and at times has had a poor rapport with farmers. However, I tried to capture the side of the fox I most respect, which is its amazing ability to observe and have a sensitive awareness of its surroundings. This is probably why the fox is so successful in nature and can adapt to an environment that most wild predators cannot. It was also my intent to portray the fox in a mixed beech and maple forest similar to those found in the farm country of Michigan, where I have often observed them. I created a visual tension by having the fox off-center and to the right, intently staring in the same direction. I tried to temper this tension by visually balancing the left side of the painting with complementary-colored clusters of leaves. I also directed the viewer's eye with the branches that gracefully curve toward the fox.

13 | EASTERN FOX SQUIRREL

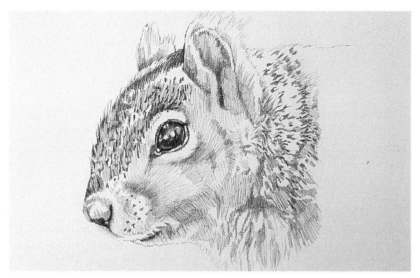

1 DRAWING ON WATERCOLOR PAPER

This is a side view of the Eastern fox squirrel. The most characteristic physical feature of the squirrel from this angle is the large, dark, almond-shaped eye. I like to refine my drawing with detail, as the transparent watercolor paint will allow most of the drawing to come through in the finished painting.

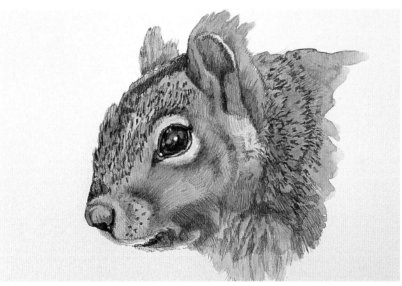

2 FIRST WASH OF THE WATERCOLOR

The face of this squirrel is broken into two distinctly colored areas. The orange-yellow areas of the nose, the ear and the side of the face are comprised of a mixture of Naples Yellow, Cadmium Yellow and Burnt Sienna. The rest of the fur is a gray-blue color made with a mixture of Ultramarine Blue and Burnt Sienna. The darkest areas of the face, such as the nose, mouth and eye, are painted with a combination of Ultramarine Blue and Alizarin Crimson. Remember that all of your lighter areas should be painted with thin washes, as it is difficult to go back and highlight these areas. Use a no. 6 round brush for both the washes and the details in the painting.

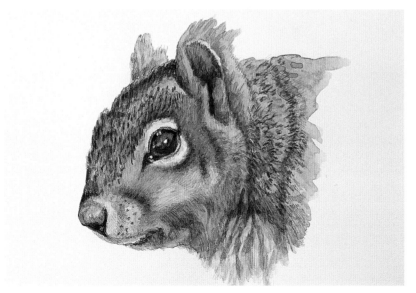

3 FINISHED PAINTING

Further refine the watercolor by adding layer upon layer of paint. When the color of the fur is accurate, define the texture by loading the brush with a darker color and making marks in line with the direction of the fur. Use black on the underside of the eye and the lower part of the nose.

EASTERN FOX SQUIRREL PORTRAIT
Kalon Baughan, watercolor on Strathmore paper,
8" x 10" (20cm x 25cm)

14 | CHIPMUNK

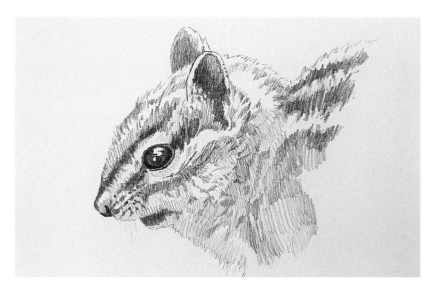

1 DRAWING ON WATERCOLOR PAPER

As in the previous demonstration, the drawing plays an integral role in the development and end result of the painting. Like the squirrel, the most characteristic feature of the chipmunk from this view is the large, dark eye. In addition, the chipmunk has distinct black and white stripes on its face and body.

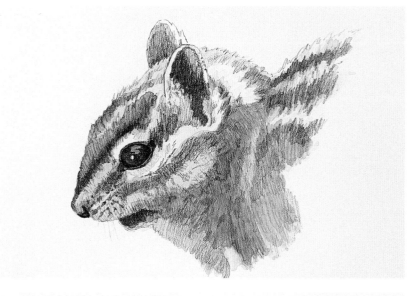

2 FIRST WASH OF THE WATERCOLOR

Begin developing the warm areas of the chipmunk with mixtures of Naples Yellow and Burnt Sienna. For the cooler areas, use mixtures of Ultramarine Blue and Burnt Sienna. The darkest areas of the chipmunk, such as the eye, mouth and ear, receive a much darker wash of Ultramarine Blue and Alizarin Crimson. Again, use thinner washes for the light areas of the chipmunk. Use a no. 6 round brush for both the washes and the details.

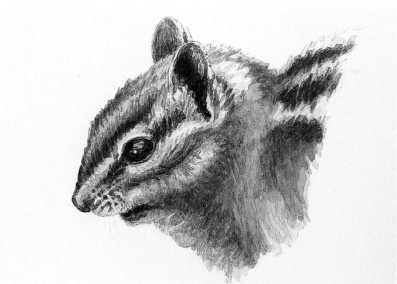

3 FINISHED PAINTING

Further refine the painting with subsequent layers of color, building up the texture of the fur and darkening the stripes. The last portion of the painting process is to sparingly use black in the darkest areas of the painting, such as in the eye, ear and nose.

CHIPMUNK PORTRAIT
Kalon Baughan, watercolor on Strathmore paper,
8" x 10" (20cm x 25cm)

PAINTING BIRDS
WITH BART RULON

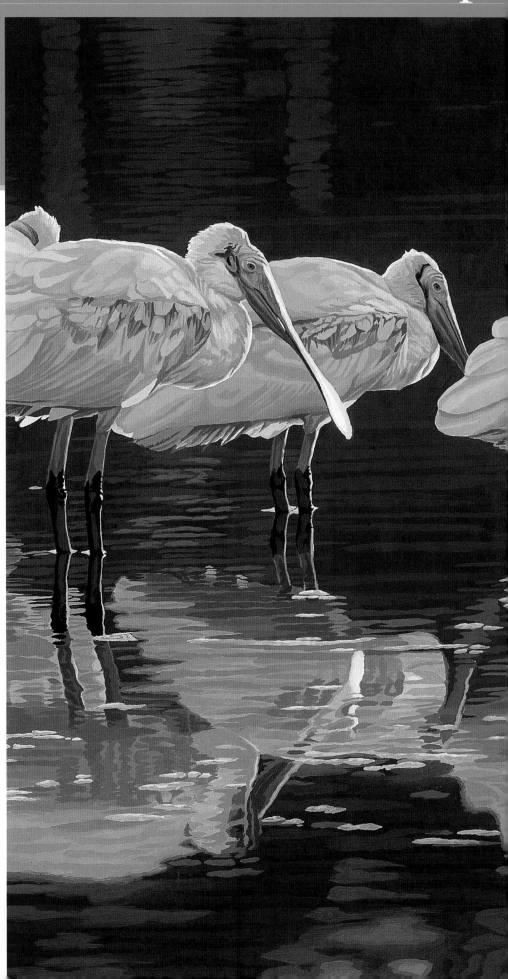

awks, eagles and owls have long been symbols of strength and survival because they must hunt and kill other animals to stay alive. Most owls hunt at night and remain out of sight, resting during the day. Hawks, eagles and falcons hunt during the day, making them easier to watch than most owls. The best places to find and research birds of prey are in areas where their prey congregates and in traditional migration routes. Birds of prey are usually hard to approach because they are always wary and alert. It requires patience, savvy and a little luck to get close to them. Most of my success photographing raptors has been in using camouflaged blinds or my car as a blind in areas with high concentrations of these birds. Some owl species can be approached with very slow and deliberate "baby steps." Be careful and watch how the bird reacts to each advance. If it becomes alarmed, freeze until the bird calms down and becomes comfortable again, or stop moving altogether.

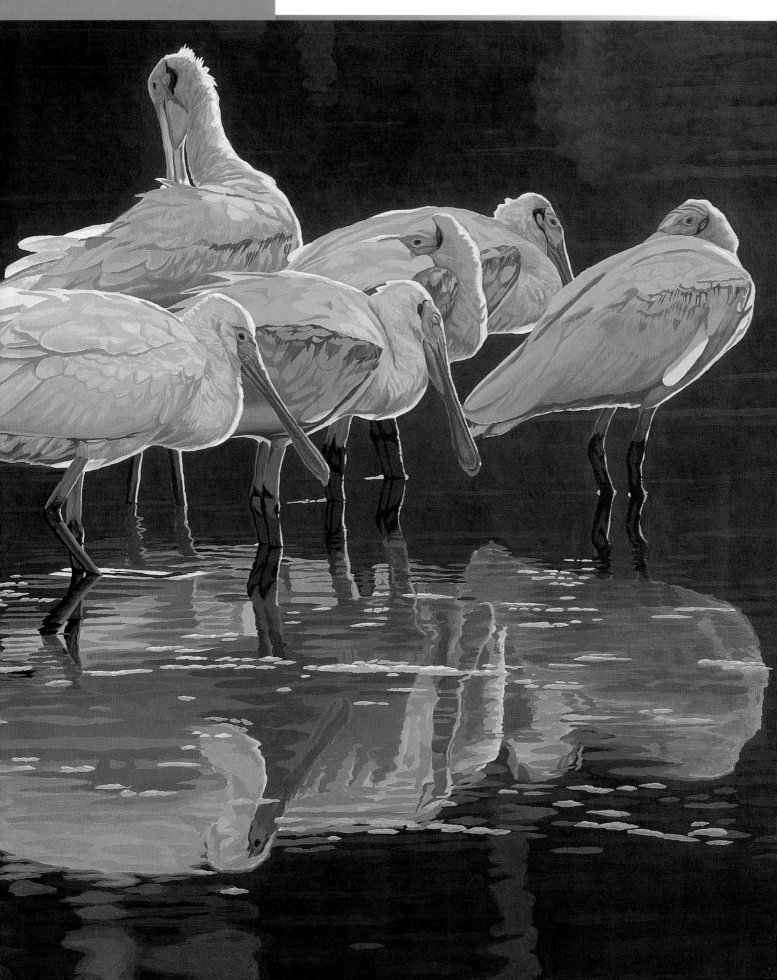

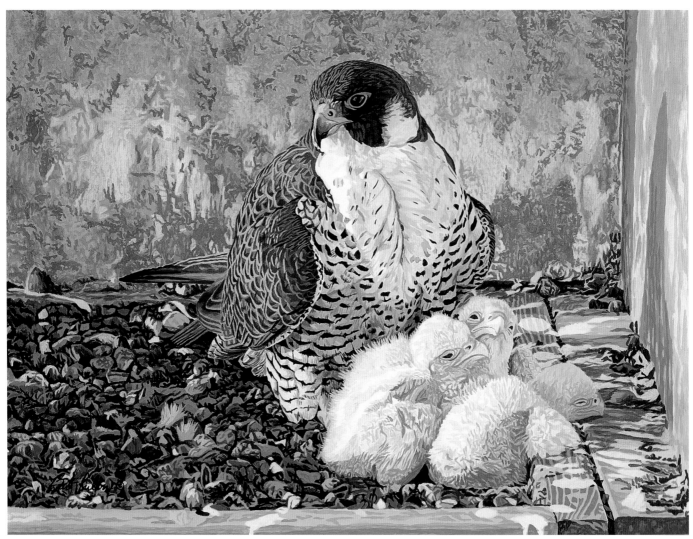

THE SEATTLE PEREGRINES
Bart Rulon, acrylic on composition
board, 9" x 12" (23cm x 30cm),
collection of Patricia Hitchens

*Peregrine falcons nest mostly
high on cliffs, but they will also
nest on the top of tall buildings in
the middle of cities. In many rap-
tor species, the cere (the yellow
area above the upper mandible
of the beak) is a different color
from the rest of the beak. The cere
is fleshy, not hard like the rest of
the beak, and it is often yellow as
on this peregrine falcon.*

irds of prey make wonderful subjects
to paint because of their great physical
presence. They have large eyes for
spotting prey, hooked beaks for tearing
flesh, and sharp talons for capturing animals.
The eyes of owls are placed forward in their
heads, giving them a more humanlike appear-
ance than other birds. Hawks, eagles and fal-
cons have a heavy brow over their eyes, which
gives them a "mean look." The hooked beak
adds to the intimidating look of raptors, making
them powerful subjects for any painting. Of all
the birds of prey, eagles have the largest and
most impressive beaks compared to head size.
The eagles and most of the hawks are built with
a broad-winged design for soaring and pouncing
on prey from above. In contrast, falcons have a
streamlined build with pointy wings to chase
birds down. No matter what bird of prey you
choose from, they all have strong physical char-
acteristics and intense personalities that make
them ideal subjects to paint.

Wading Birds

Shorebirds, herons, egrets, rails, waterfowl and
other wading birds are found in aquatic habitats
that offer a wealth of artistic possibilities and are
among my favorite birds to paint. The birds
themselves are diverse and colorful. They have
many interesting behaviors and are found alone,
in large flocks or in groups of mixed species. All
this gives you many compositional options.

Different species of wading birds can be
found in almost any kind of water ranging from
salt to fresh or from ocean beach to marshland.
Some of the best places to find and research
wading birds are at national wildlife refuges,
tidal beaches and shallow marshlands. These
are often gathering places for huge numbers of
migrating or resident birds. Some wading bird
species are easier to approach than others. With-
in a species, the ability to get close to a bird
often depends on the location. A species that is
unapproachable in a wild setting might be al-
most tame in another area where it sees people

GREAT EGRET AND WHITE IBISES
Bart Rulon, watercolor on Arches paper, 28" x 40" (71cm x 102cm), collection of Paul and Deborah Zimmerman

Different species of wading birds often share the same habitats, such as the great egret and white ibises depicted here. Egrets and herons have spearlike beaks for capturing fish with quick strikes of the head. The long, down-curved beaks of ibises and other similar waders are designed for probing around in the water and mud for small aquatic life. Notice the bare red skin on the faces of the adult white ibises. The amount of bare skin is not as extensive on the brown immature ibises.

on a regular basis. Approaching timid wading birds usually requires the use of a stationary blind, floating blind or a kayak. This way you can photograph birds at close range that are not approachable on foot.

Aside from body shape and color, the beaks of wading birds are the main articles that distinguish their faces from one species to the next. The bills of wading birds are built specifically for what they feed on. For instance, the roseate spoonbill has a literally spoon-shaped beak that it uses to feed by feel rather than by sight. The beaks of shorebirds vary tremendously and can range from the thin upturned bill of the American avocet to the long down-curved beak of the long-billed curlew. Some wading birds, such as roseate spoonbills, ibises, herons and egrets, have bare skin stretching from their beaks to their eyes. This wide diversity of physical characteristics and habitat preferences makes wading birds great subjects for any artist.

ROSEATE SPOONBILLS AT LOW TIDE
Bart Rulon, watercolor on Arches paper, 17½" x 24" (44cm x 61cm), collection of Dr. Norman and Pat Roland

The roseate spoonbill has one of the most unusual faces in all the bird world. The adults have bare green skin on their heads reaching all the way back to their ears and a long spoon-shaped beak. The bare skin on the face of immature spoonbills (the one on the lower left side) is not as extensive as in the adults.

15 | GOLDEN EAGLE

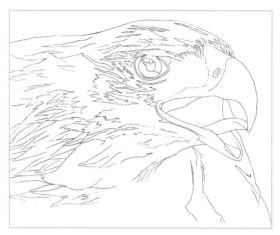

1 PRELIMINARY DRAWING
Carefully draw the eagle's head with the major details of the feathers, eye and beak included.

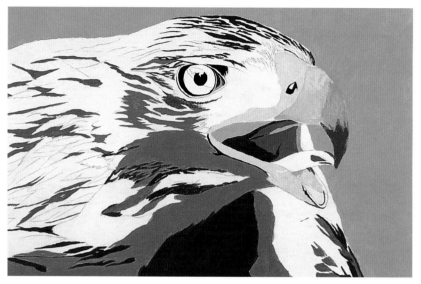

2 INITIAL COLORS
Using acrylics, paint the pupil of the eye with a mixture of Ivory Black, Raw Umber, Ultramarine Blue and Titanium White. Add a little more Titanium White and Raw Sienna to that mix for painting under the brow and Scarlet Red (Cadmium Red Light Hue) for the dark part of the nostril. Paint the cere with a mix of Grumbacher acrylic Cadmium-Barium Yellow Light, Titanium White and a touch of Raw Sienna. Block in the end of the beak with a mixture of Ultramarine Blue, Ivory Black, Titanium White and Scarlet Red. For the lighter part of the beak, use a mixture of Ultramarine Blue, Titanium White and a touch of the mix from the tip of the beak, with varying amounts of Titanium White added. For the reddish areas on the inside of the mouth, use a mix of Scarlet Red, Ultramarine Blue, Ivory Black and Titanium White. For the darkest areas inside the mouth, add more Ultramarine Blue, Ivory Black and Naphthol Crimson to this first mix. Block in the darkest feathers on the head with a mixture of Raw Umber, Raw Sienna, Ivory Black, Ultramarine Blue and Titanium White with a no. 3 round brush. For the feather streaks that are a little lighter, take the first mix and add Titanium White and Raw Sienna.

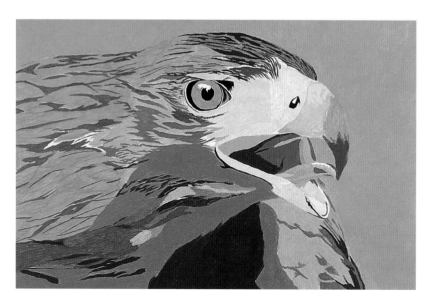

3 BLOCKING IN THE FEATHERS
Paint the golden areas on the eagle's neck using a mix of Raw Sienna and Titanium White with a no. 12 flat brush. Use the same mix to block in the eye with a no. 1 University Gold round brush. Take some of this mixture, add Raw Umber and Titanium White to it, and paint the lightest feathers on the eagle's head using the no. 1 University Gold round brush. Add some Ultramarine Blue and Titanium White to form the base for the lore (the area between the eye and the beak). For the lighter areas of the lore, add more Titanium White to this mixture and paint them in with a no. 3 Sceptre Gold round brush. Block in the tongue using the no. 3 University Gold round brush and a mix of Scarlet Red, Naphthol Crimson and Titanium White. Paint the lighter areas of the tongue by adding more Titanium White to the first tongue mixture and use a no. 1 round brush.

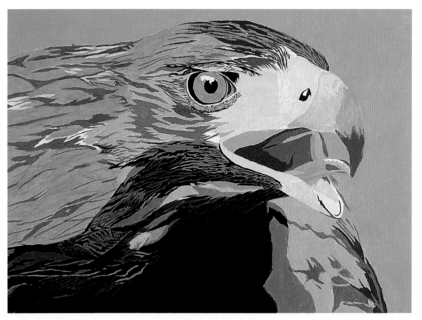

4 DARK FEATHER PATTERNS

Mix Raw Umber, Ivory Black and a bit of Titanium White to paint dark feather patterns on the chin and throat with a no. 1 Sceptre Gold round brush and a no. 1 University Gold round brush. Use the same mixture to paint dark feather patterns on the breast. To go back and forth between darks and lights in these areas, take the same mixture and add varying degrees of Titanium White and Raw Sienna. Paint the subtle feather details under the eye with a no. 2/0 round brush and a mix of Ultramarine Blue, Raw Umber, Raw Sienna, Titanium White and Ivory Black. Fill in between the dark streaks on the chin with a mixture of Raw Umber, Ivory Black and Titanium White.

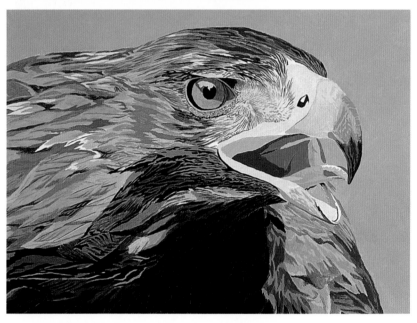

5 FEATHER DETAILS

Make several different value mixtures consisting of Raw Umber, Ivory Black, Ultramarine Blue and Titanium White to work in the details of the lore. Paint a mixture of Raw Sienna, Raw Umber and Titanium White to indicate where the shadow from the eagle's heavy brow will hit the eye. Take a mix of Raw Sienna, Raw Umber and Titanium White and paint it on the cheek as an intermediate color between the lights and darks. Add more Titanium White to that mix and paint it on the lightest areas of the gold-colored neck. Make five to six mixes of brown ranging in value from very light to very dark. Paint these mixtures wherever they are found in the feathered parts of the eagle. Use a mix of Ultramarine Blue, Scarlet Red, Ivory Black, Titanium White and a touch of Raw Umber to make the shadow on the lower mandible. For the beak's tip, mix Ivory Black, Ultramarine Blue, Scarlet Red and a bit of Titanium White to paint the darkest values.

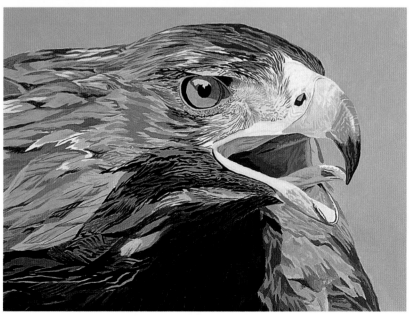

6 MORE DETAILS

Mix Ultramarine Blue, Titanium White, a touch of Ivory Black and Cadmium-Barium Yellow Light to add some gray modeling on the cere, around the nostril. For the lightest areas of the cere, make a very light mix of Titanium White and Cadmium-Barium Yellow Light. Mix Ultramarine Blue, Titanium White, Ivory Black and Scarlet Red to paint more shading on the middle part of the beak. Add Titanium White for the very top of the beak. For the lightest part of the mouth, use Scarlet Red, Ultramarine Blue, Cadmium-Barium Yellow Light and Titanium White. Add Naphthol Crimson to this mixture for the reddish areas. Blend four mixtures of Ultramarine Blue, Naphthol Crimson, Ivory Black and Titanium White from light to dark. Paint these inside the mouth and make additional intermediate mixes to blend them together with a no. 1 round brush.

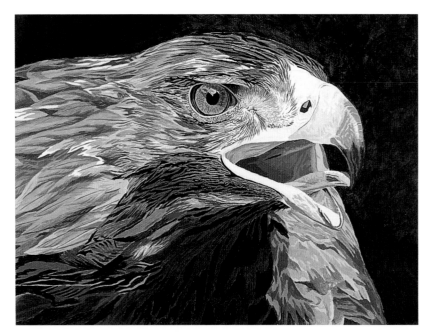

7 FINISHING UP

To paint more detail in the iris of the eye, start with the portion that is in shadow. Mix equal parts of Raw Sienna and Raw Umber, and paint detail in the iris with a no. 2/0 round brush. For the lower part of the eye, hit by sunlight, use a mix of Raw Sienna and Burnt Sienna. Glaze this mix on the iris to show the patterns in the eye with a no. 2/0 round brush. To dull down the highlight in the eye, mix Ultramarine Blue, Scarlet Red, Ivory Black, Raw Umber and Titanium White. Vary the amount of white in the highlight. Continue to add more details to the feathers, working back and forth from light to dark, using no. 3, no. 1, and no. 2/0 round brushes.

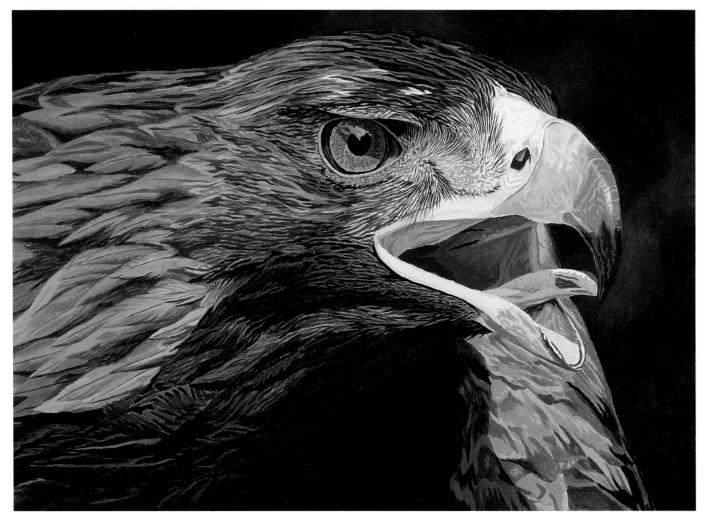

GOLDEN EAGLE
Bart Rulon, acrylic on composition board, 9" x 12" (23cm x 30cm)

Comments on the Finished Painting

Reevaluate the painting during the last stage and add any finishing details you feel are missing. The amount of lighter feathers varies from individual to individual, so changes you make will not seem to be inaccurate. Finish the details by working back and forth from dark to light. When adding details, step back often to make sure the overall values, shadows and lighting look good. When all of these aspects look consistent with your reference and the eagle looks realistic, then the painting is finished.

16 | IMMATURE PEREGRINE FALCON

1 PRELIMINARY DRAWING

Complete an accurate drawing of the dimensions of the falcon, paying special attention to the distance between the beak and the eye and their relative sizes compared to the head. Include all the feathers and feather markings on the sketch paper, working out all the mistakes. Make sure the anatomy is correct before transferring the drawing to the painting surface.

2 INITIAL BLOCKING

The first painting step using acrylics is to block in the dark feather markings with a no. 3 round brush. Then, block in the lighter colors of the feathers.

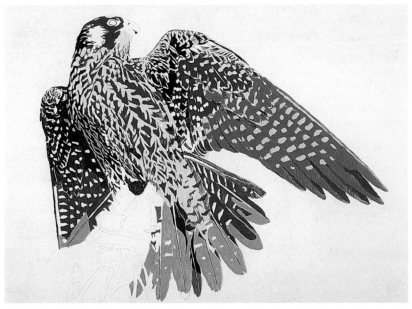

3 ADD DETAILS

The eye starts with a simple covering of a dark color mixed with Ultramarine Blue, Raw Umber and Ivory Black. Paint over top of this with a slightly lighter color of brown mixed with Ivory Black, Burnt Sienna, Raw Umber and Titanium White to indicate the iris (which would barely be seen upon close observation in this lighting situation). Block in the initial color on the beak with an Ultramarine Blue, Ivory Black and Titanium White mixture and a no. 3 round brush. After this first coat is dry, glaze a mixture of Raw Sienna, Raw Umber and Titanium White on top toward one side with a no. 1 round brush. At this point the shadows and average color of the end of the beak are blocked in with minimal blending between their edges.

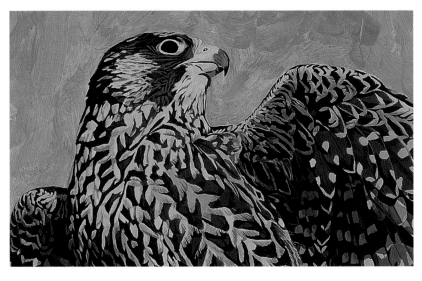

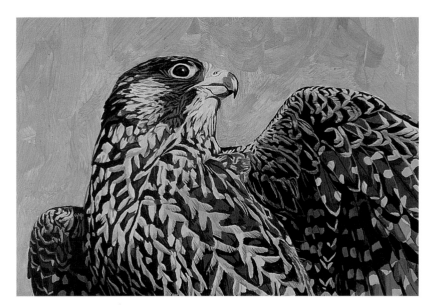

4 FINAL DETAILS

Add a slight bluish glaze to the top quarter of the eye, where it is facing the sun, with a mix of Ultramarine Blue, Burnt Sienna and Titanium White. Paint a white highlight slightly overlapping the pupil with the no. 1 round brush to indicate the sun's reflection. Add a shadow to the mouth line, indicating the form of the beak there. Next, glaze a white highlight on the beak reflecting from the bright sun. Finally, darken the shadow on the bottom of the lower beak. Use the no. 1 round brush for all these procedures.

With the major work done, most of the changes are subtle. Apply a warm glaze of Raw Sienna to the edges of the cheek marking to help indicate the warmth of the sun. Finally, paint a background of blue to help emphasize the warmth of the sun on the falcon.

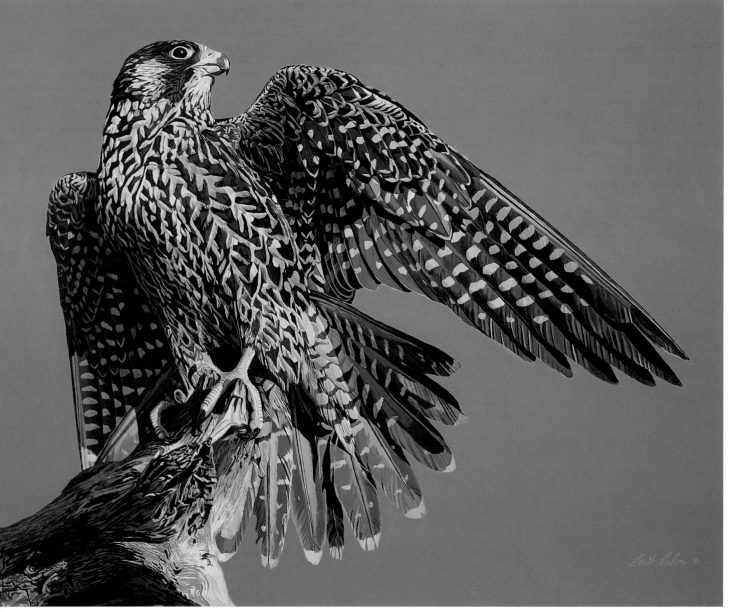

IMMATURE PEREGRINE FALCON
Bart Rulon, acrylic on composition board, 15½" x 20" (39cm x 51cm), private collection

Comments on the Finished Painting
Notice how the position of the head, looking back, adds to the uniqueness of this peregrine falcon portrait.

17 | AMERICAN AVOCET

1 PRELIMINARY DRAWING

Draw out the dimensions of the avocet, paying special attention to the length and curve of the beak. Always be careful about the placement of the eye, its distance from the beak and the top of the head. Draw the edges of the shadow on the neck. Do not draw the feathers in yet as they will be saved for the painting stage.

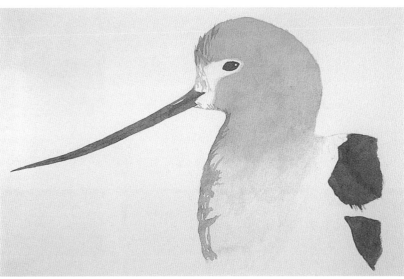

2 INITIAL WASHES

After transferring the drawing to watercolor paper, paint a wash of color on the beak and eye using a mixture of Neutral Tint, Burnt Umber and Raw Umber. Paint the first wash of color on the head using a blend of Cadmium Orange, Raw Sienna and Burnt Sienna and a no. 6 round brush. Start the blue shadow on the front of the avocet's face with a mix of Ultramarine Blue and Winsor & Newton's Permanent Alizarin Crimson and a no. 3 round brush. Then add Burnt Sienna and Burnt Umber to this previous blue mix to paint the shadow on the neck, where the local color is orange.

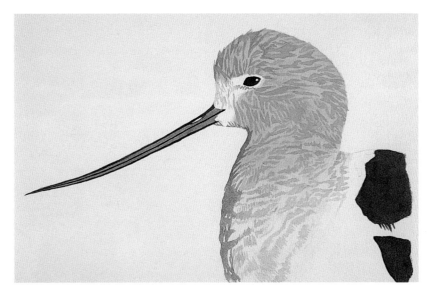

3 ADD DETAILS

Darken the eye with a no. 1 round brush and a mix of Burnt Umber and Neutral Tint. Use the same mix to put in dark layers on the bottom, top and middle of the beak. Look at your reference photo closely to paint the patterns of feathers on the head and neck, using Raw Sienna, Cadmium Orange and Burnt Sienna and the no. 1 round brush.

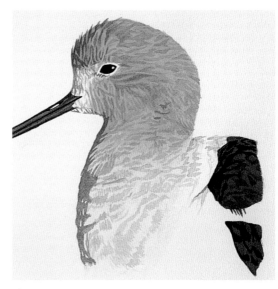

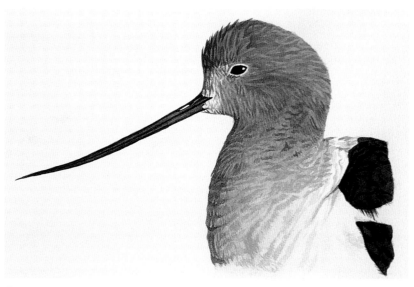

4 MORE DETAILS

Darken the eye again and block in dark patterns on the black part of the wing with the same mixture of Burnt Umber and Neutral Tint using the no. 1 and no. 3 round brushes respectively. Darken some of the orange feather markings on the head with the no. 1 and no. 3 round brushes and a mix of Raw Sienna, Cadmium Orange and Burnt Sienna. Give the head another wash of the same orange color using the no. 6 round brush. Next, darken the blue shadows on the face with a mix of Ultramarine Blue and Permanent Alizarin Crimson. Darken the shadow on the chin and neck with a mix of Ultramarine Blue, Permanent Alizarin Crimson and Burnt Sienna. For the feather markings on the forehead, paint the shadow with a cool mix of Ultramarine Blue, Permanent Alizarin Crimson and Burnt Umber. For these last three procedures, use the no. 1 and no. 3 rounds.

5 FINISHING UP

To finish the avocet, alternate between painting washes of a mix of Raw Sienna and Cadmium Orange and painting fine feather details with Raw Sienna and Burnt Sienna. Save painting the feathers with hard edges for last after the broad washes are finished. Washes tend to blend the edges of marks painted under them. Thus, by washing over some feathers and saving other markings for the very last step, it creates the illusion of depth. Also, darken the shadows on the neck, using the same colors and brushes as before. Finally, darken the eye to its final value, making the outside part almost pure black and the middle of the eye just slightly lighter.

AMERICAN AVOCETS
Bart Rulon, watercolor on Arches paper, 22" x 30" (56cm x 76cm)

Comments on the Finished Painting
The face of this avocet is important in making the painting work because it is one of the few birds that is not in a resting pose. Having a combination of different poses, with some birds resting and some birds awake, makes for a lifelike and interesting composition. The few birds that are fully awake provide a focal point for the viewer while the resting birds add a variety of shapes and attitudes to the composition.

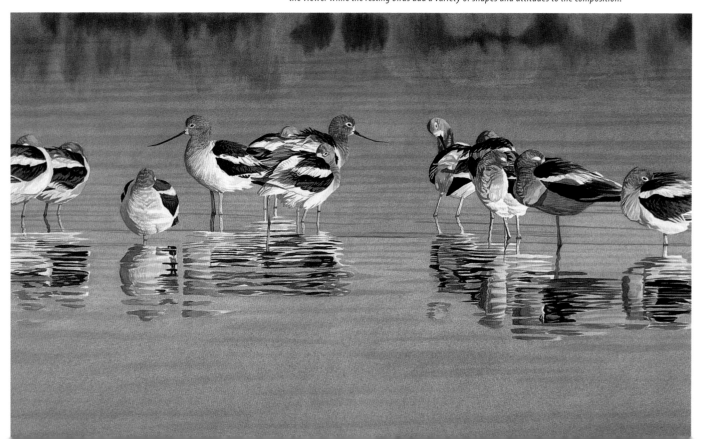

18 | ROSEATE SPOONBILL

1 PRELIMINARY DRAWING

Carefully draw in the details of the spoonbill's head on scrap paper and transfer it to a gessoed composition board or canvas. Now you are ready to start painting in acrylics.

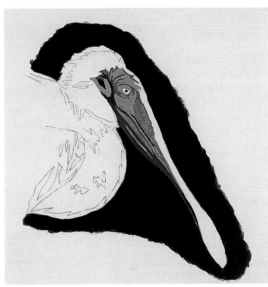

2 FACIAL COLORS

Paint the main part of the ear patch with a no. 3 brush and a mixture of Ivory Black, Titanium White, Ultramarine Blue, Cadmium-Barium Yellow Light and Raw Umber. Add more Titanium White for the surrounding areas of the ear patch. Supplement this second mixture with even more Titanium White to paint the creases in the bare green skin of the face. Lighten this mixture with more Titanium White and Cadmium-Barium Yellow Light to fill in the areas on the face between the creases with a no. 3 round brush. Use a mixture of Raw Umber, Ivory Black, Ultramarine Blue and Titanium White for the dark areas on the beak. For the lighter areas of the beak, use the same mixture but with more Titanium White and Raw Sienna added, using a no. 3 round brush.

3 INITIAL FEATHER COLORS

With a no. 3 round brush, paint a mix of Ultramarine Blue, Naphthol Crimson, Titanium White and Ivory Black in the darkest parts of the neck and forehead. Add a little Titanium White to this mixture for the parts of the neck that are just a shade lighter. Combine Titanium White and Naphthol Crimson with this last mixture, making it more reddish, and apply this to the shoulder area above the wing with a no. 3 round brush. Then take that mix and add more Naphthol Crimson in order to block in parts of the wing. Use varying degrees of Titanium White for subtle value differences. Block in the lightest part of the pink wing, using a no. 1 University Gold round brush with a mix of Naphthol Crimson, Titanium White and a touch of Ultramarine Blue.

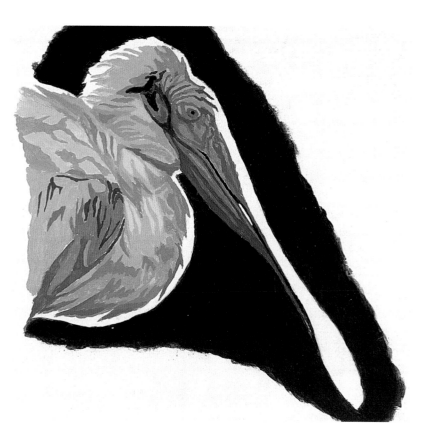

4 ADD DETAILS

Mix Ultramarine Blue, Scarlet Red, Titanium White and a bit of Ivory Black to block in the lightest parts of the neck. Add Naphthol Crimson and more Titanium White to this mix to finish blocking off the shoulder area with a no. 3 round brush. Start the eye with a no. 2/0 round brush and a mix of Naphthol Crimson, Scarlet Red and Titanium White. Paint the darkest parts of the neck with a mix of Ultramarine Blue, Scarlet Red, Ivory Black and Titanium White. Add more Titanium White to blend between the base color and the new color. For dark shading on the beak, paint a new mix of Raw Sienna, Raw Umber, Titanium White and Ultramarine Blue using a no. 3 round brush. Brush in the mouth line using a no. 1 round brush and a mix of Ivory Black and Raw Umber. Paint different values in the face with a mix of Ultramarine Blue, Cadmium-Barium Yellow Light, Scarlet Red, Ivory Black and Raw Umber using a no. 1 round brush. Finally, add different amounts of Titanium White to this last mixture for working back and forth between the dark and light details in the face.

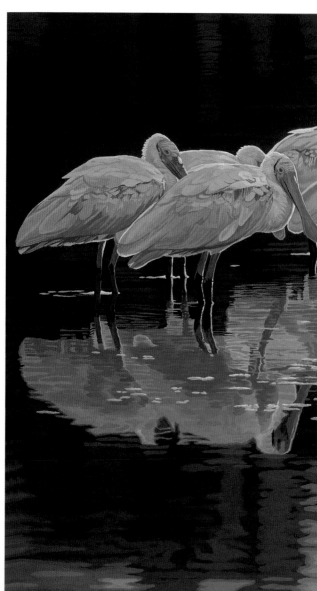

ROSEATE SPOONBILLS
Bart Rulon, acrylic on composition board, 28" x 48" (71cm x 122cm)

Comments on the Finished Painting

When several birds are grouped together in a composition like this, the group itself makes for a great subject. It is important to represent each bird in the flock accurately, but you do not have to paint the same amount of detail that would be required with a single bird portrait. Within a flock of birds, I like to make one or two of them the focus. Here I draw your attention to the spoonbill painted in the demo by creating a break in the line of birds right in front of the bright glare reflecting off its beak.

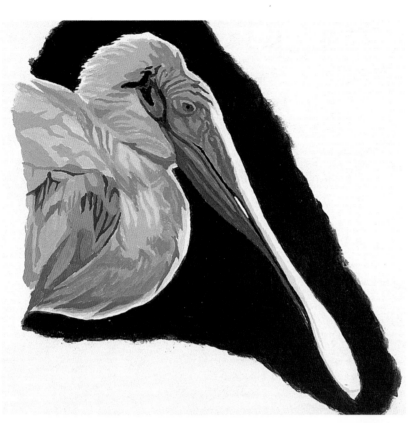

5 FINISHING UP

Use several mixtures of Naphthol Crimson, Ultramarine Blue and Titanium White with different amounts of Titanium White added to paint the variations in color on the wing. Use the no. 1 and no. 3 round brushes. Glaze a warm mixture of Ultramarine Blue, Naphthol Crimson, Raw Sienna and Titanium White on the underside of the spoonbill's neck with a no. 3 round brush. Then paint the feather edges on the back of the head with pure Titanium White and a no. 2/0 round brush. To warm up the white halo effect caused by backlighting, paint a warm glaze consisting of Scarlet Red, Raw Sienna and Titanium White on the inside edge of the halo. For the leading edge of the beak, paint a light mixture of Titanium White and Cadmium-Barium Yellow Light to further indicate the warmth of the sun. Finally, darken the upper part of the spoonbill's eye with the no. 1 round brush using a mix of Naphthol Crimson, Ultramarine Blue and Titanium White.

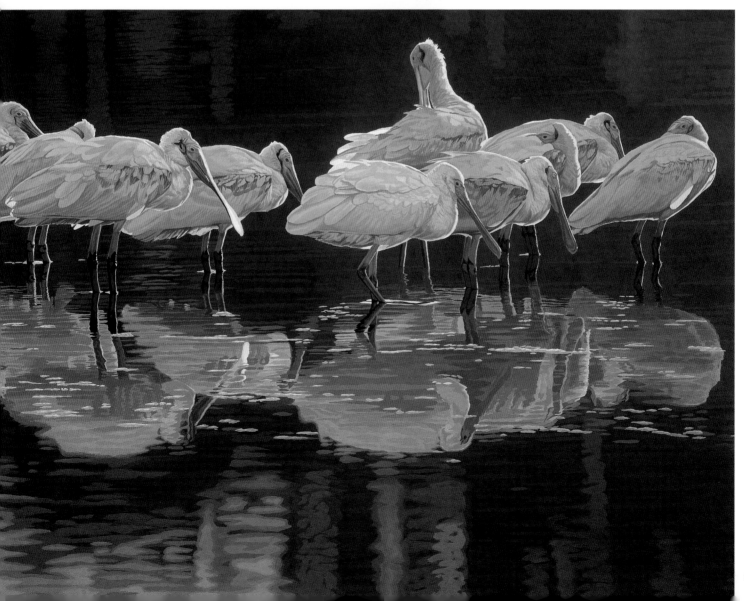

I would like to leave you with a few concepts that I find meaningful and valuable in my own career as an artist. First of all, the majority of my time as an artist is spent in solitude, painting in my studio; therefore, I greatly appreciate the time that I spend interacting with other artists and discussing our work. I encourage you to find people with whom you can share your art enthusiasm. It is important to expose your mind to other artists' ideas. This can help keep your art fresh.

Secondly, if you want to paint wildlife art, I suggest that you get to know your subject matter on some kind of a profound level. I encourage you to primarily paint animals that you have actually seen and not to rely solely on reference material taken from magazines, videos or purchased from professional photographers. I met a man in 1994 at Point Pelee National Park in Canada who was a quadriplegic as a result of a recent motorcycle accident. He was determined to photograph all of the birds of prey of North America in the wild and had almost completed his daunting task, lacking only a few species. From his specialized wheelchair, he could operate his camera with air pressure from his mouth—a system he designed himself. This man has inspired me ever since I met him, and he has made me realize that where there is a will, there is a way.

Last but not least, even when you are not feeling inspired, you must work. Vincent van Gogh once said, "If you hear a voice within you saying, 'You are not a painter,' then by all means paint, . . . and that voice will be silenced." For me, this means that the act of painting itself can nurture the artist within you. It is a good idea to support your studio painting with time spent painting in the field or with a live model. I also suggest taking time out to visit galleries and museums for inspiration and to broaden your perspective on art. These activities can help you to get back to the fundamentals of art and revive your drive to create. Painting wildlife has greatly enriched my life, and I hope that this book inspires you to explore your own talents within this genre. As my grandfather "Colonel" Paul Good has always said to me as I am about to embark on new challenges, "Charge on—have no fear!"

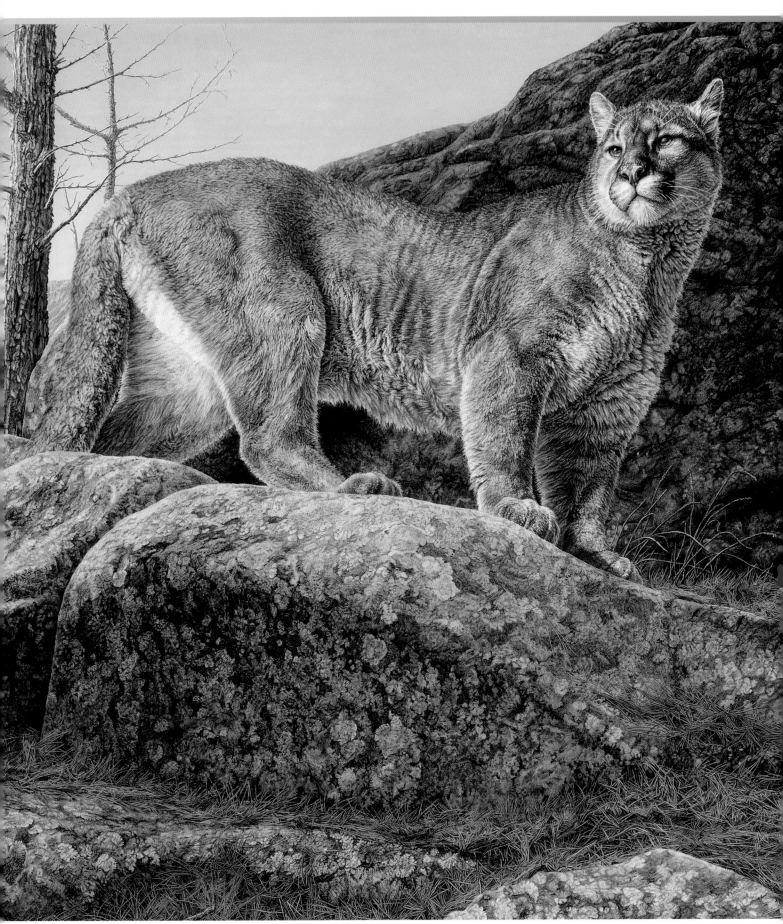

MOUNTAIN SENTRY
detail, Kalon Baughan, oil on canvas, 36" x 48" (91cm x 122cm), collection of Bob and Ann Good

Bart Rulon photographing birds from a kayak in Ding Darling National Wildlife Refuge, Florida. (photo by Kalon Baughan)

BART RULON

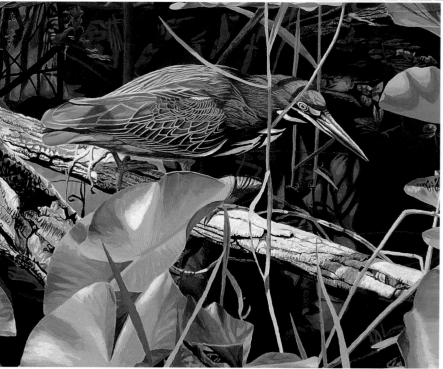

GREEN HERON IN THE EVERGLADES
detail, Bart Rulon, acrylic, 18" x 34" (46cm x 86cm)

Born in 1968, Bart Rulon lives and works on Whidbey Island in Washington State's Puget Sound. He received a bachelor's degree from the University of Kentucky in a self-made scientific illustration major. He graduated with honors and became a full-time artist, focusing on wildlife and landscape subjects, specializing in birds.

Rulon's works have been exhibited in many of the finest exhibitions, museums and galleries displaying wildlife and landscape art in the United States, Canada, Sweden, Japan and England. His paintings have been included in ten exhibitions with the Leigh Yawkey Woodson Art Museum, including seven times with the "Birds in Art" exhibit and one each in their "Wildlife: The Artist's View," "Natural Wonders" and "Art and the Animal" exhibits. His work has been chosen for the Society of Animal Artists' annual exhibition "Art and the Animal" for all seven years since he became a member. His paintings have been included in the Arts for the Parks Top 100 exhibition and national tour five times, and in 1994 he won their Bird Art Award. His paintings and sketches of birds are included in the permanent collections of the Leigh Yawkey Woodson Art Museum, the Bennington Center for the Arts and the Massachusetts Audubon Society.

Rulon's paintings have been featured on the cover and in the interior of many *Bird Watchers Digest* issues. His illustrations of seabirds appear in the field guide *All the Birds of North America* (HarperCollins, 1997), and he was commissioned to paint a variety of birds for *A Guide to the Birds of the West Indies* (Princeton University Press, 1998). He is the author of *Painting Birds Step by Step* (North Light Books, 1996) and *Artist's Photo Reference: Birds* (North Light Books, 1999), and he has been featured in three other North Light books: *Wildlife Painting Step by Step* (Patrick Seslar, 1995), *The Best of Wildlife Art* (edited by Rachel Rubin Wolf, 1997) and *Keys to Painting: Fur & Feathers* (edited by Rachel Rubin Wolf, 1999). His work is also included in the book *Wildlife Art* (Rockport Publishers, 1999).

Rulon's primary interest is in experiencing his subjects firsthand in the wild. He focuses on painting subjects and scenes he has experienced in the wild rather than trying to paint those he's never seen. Rulon prides himself on the time he spends in the field researching his subjects, because this is what he enjoys the most about being an artist. It's that personal experience that inspires him to re-create an image, more than the act of painting itself.

Hobbies that occupy Rulon's time when he's not painting include fishing, kayaking, beach volleyball, basketball, soccer, weight lifting, bird-watching and camping.

INDEX

INDEX